AN INTRODUCTION TO

DRAWING

AN INTRODUCTION TO

DRAWING

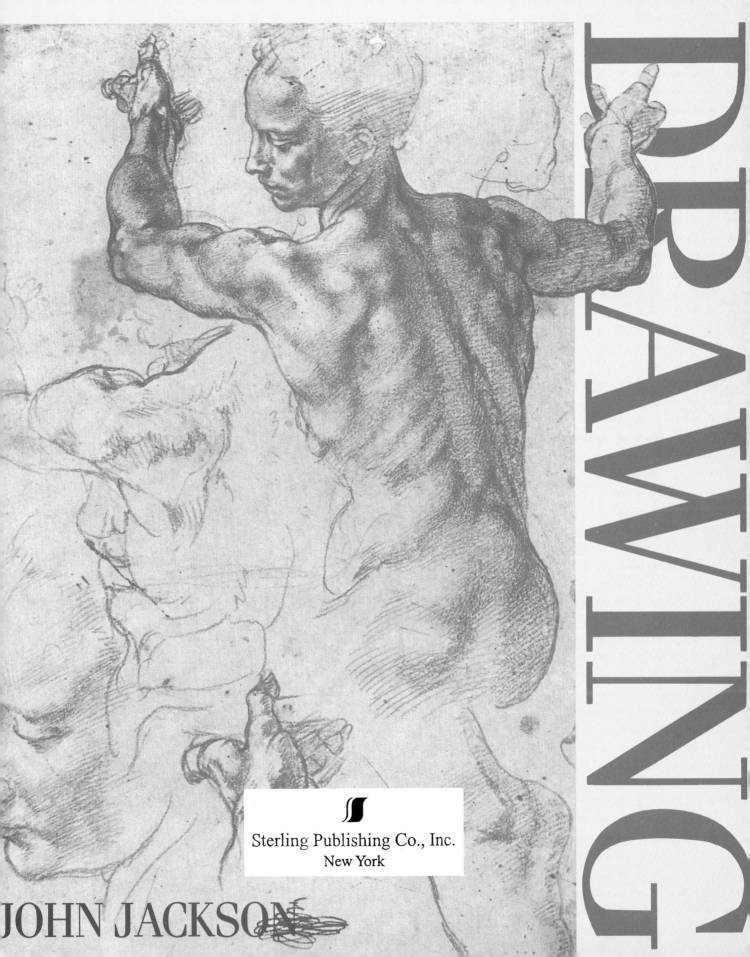

Sterling Publishing Co., Inc.
New York

JOHN JACKSON

A QUANTUM BOOK

Library of Congress Cataloging-in-Publication Data is
available upon request

1 3 5 7 9 10 8 6 4 2

Published in 1998 by Sterling Co., Inc.
387 Park Avenue South
New York, NY 10016

Copyright @ 1991 Quintet Publishing Limited

This edition printed 1998

QUMIND

This book is produced by
Quantum Books Ltd
6 Blundell Street
London N7 9BH

Printed in Singapore by
Star Standard Industries Pte Ltd

ISBN 0-8069-3783-1

CONTENTS

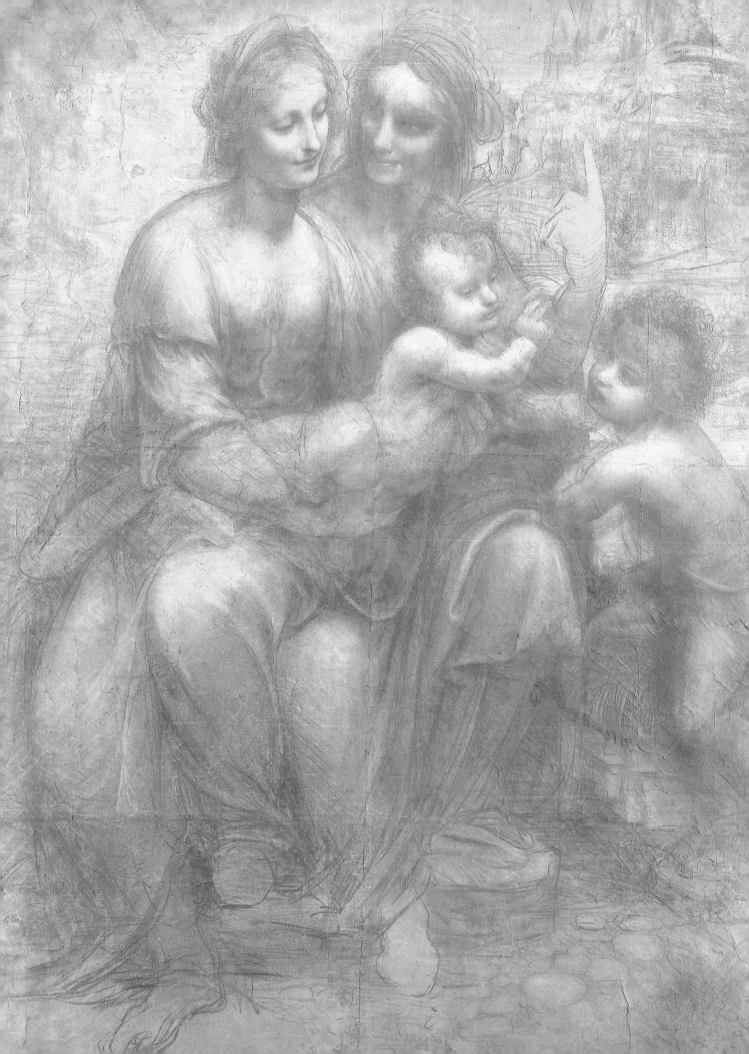

INTRODUCTION

This drawing in the National Gallery, London, by Leonardo da Vinci, represents one of the greatest achievements in draughtsmanship. It is one of a whole series of drawings of this subject culminating in a painting now in The Louvre in Paris.

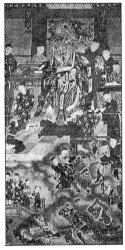

A B O V E *The oriental drawing of Yama, King of the Seventh Hell, is an example of another form for representation. Here the King, being the most important figure and main subject matter of the painting, is depicted much larger than the other figures. This is quite logical, but is a different system of representation than that assumed in the Leonardo drawing.*

*I*T IS OFTEN a great surprise the first time to discover the range of images and techniques to be found in the art of drawing. The dictionary definition is far too narrow to be of any real value in understanding the breadth of work that an art historian would include in the category of drawn images. However, many people still think that drawing is carried out only with a pencil and that it consists mainly of outlines.

Presented with the image of Ruskin's drawing *The Market Place, Abbeville* (overleaf), everyone would agree that this is a drawing. However, Degas' pastel drawing of a woman at her toilet *Après le bain, femme s'essuyant* (page nine) might cause some confusion, particularly as this work in pastel is in full colour. Close study of the Degas reveals that it is made up of small lines of colour which are quite separate on the surface. The common link between the Degas and the Ruskin is that both utilize a line. Even though the Degas is in full colour the technique employed makes it very clearly a drawing, not a pastel painting.

In the drawing by Seurat of a young bather (page 10), the linear construction of the drawing is far less obvious: the charcoal has been used on a very coarse-grained paper that breaks the line up into a series of tones and dots that appear to fuse completely with the paper. The concern of the artist in this drawing has been the effect of light falling on to the figure; and hard lines would destroy the quality of light by making the edges too defined and hard.

The three examples have all been executed with a dry medium. Again, it can be something of a surprise to discover for the first time that a number of wet media are also included in the art of drawing, such as ink used with pen and brush. In the drawing of his wife having her hair combed, Rembrandt applied the large dark areas with a brush, and it is only in those parts of the drawing that are well lit that we find lines drawn with a pen denoting in detail the hands and the heads (page nine). The Rembrandt drawing brings the two extremes represented in Seurat's drawing and Ruskin's drawing together in one technique and finely balances tonal mass and line. The drawing covers a broad spectrum of approaches and is an excellent

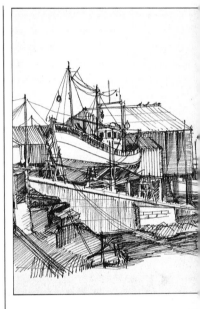

In this drawing of a shipyard, a felt tip pen has been used on a smooth cartridge paper. The felt tip pen, when used with sensitivity, can produce a clear and interesting image.

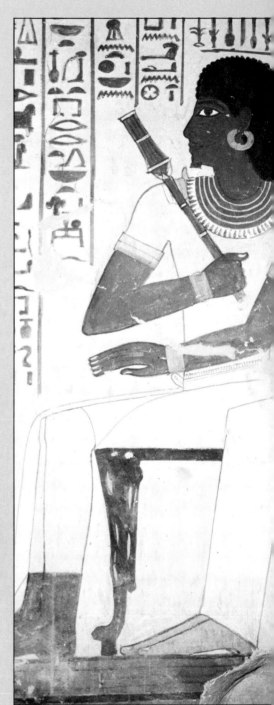

RIGHT *This Egyptian wall painting is one small section of a mural in the tomb of an Egyptian pharoah. The figures obey none of the rules of three-dimensional perspective. They and the objects round them are represented in the flat form of a pattern, and each object, including the figures is depicted in such a way as to display its most characteristic aspects. For example, you see the heads in profile, but the eye is drawn as though in full face, the legs are drawn in profile from the side, but the shoulders and arms are drawn from the front. This is just as logical, but very different, to the Leonardo drawing.*

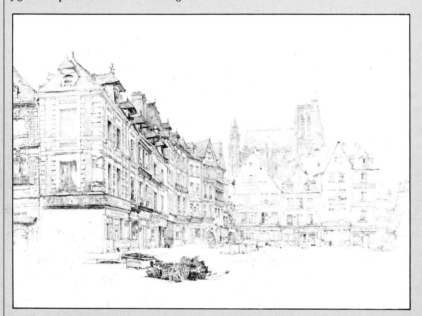

ABOVE *This finely rendered pencil drawing,* The Market Place, Abbeville *by John Ruskin, is unmistakably a drawing. It is constructed mainly of line, and the architectural perspective gives a sense of the three-dimensional space. Atmospheric space is achieved by using a lighter line for the buildings at the end of the square, which makes them appear further away.*

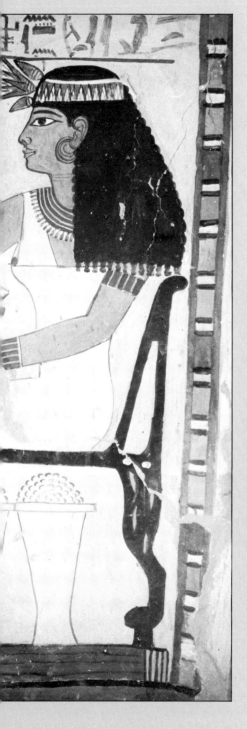

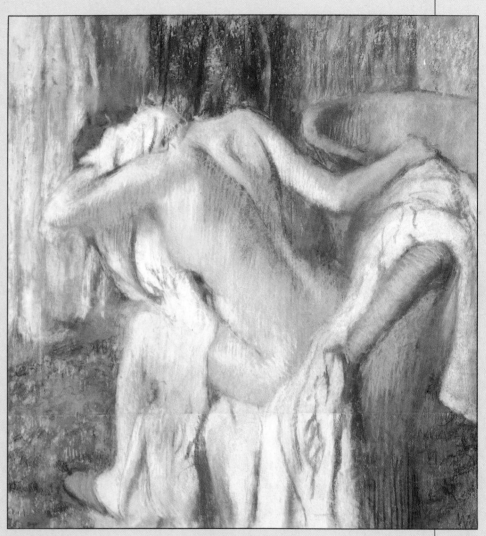

ABOVE Après le bain, femme s'essuyant (Degas). *This pastel drawing of a girl drying her hair may not be as obviously a drawing as the Ruskin. On closer inspection, however, it will be seen that the colour has been applied with pastels in short regular lines. These lines indicate the flow and direction of the form they are describing.*

RIGHT *In this drawing by Rembrandt of his wife having her hair combed, we see the use of a wet medium. The large dark areas have been applied with a brush, and the details picked out with a pen. There is a strong relationship between Rembrandt's ink drawing technique and his etching technique, where he employed the same contrast between light and dark.*

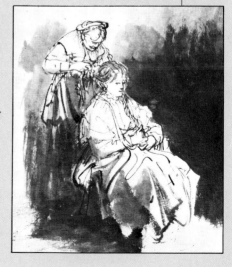

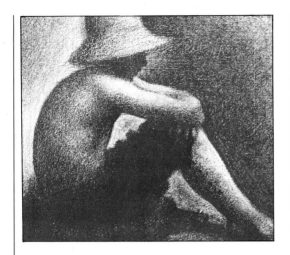

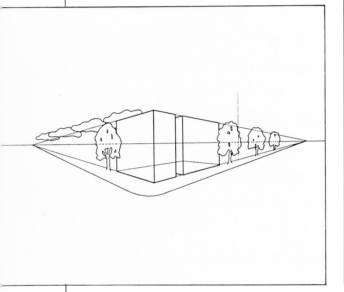

ABOVE RIGHT
A charcoal drawing on coarse paper; a combination which enhances the contrast between light and dark.

ABOVE *To ensure a basic understanding of this diagrammatic drawing of perspective and the picture plane will be one of the main aims of this book.*

TOP *In this drawing of a young boy by Georges Seurat, the line is expressed as an edge between light and dark form, and the softness of the edges is achieved by using a coarse grained paper which breaks the line into small individual chalk marks.*

pointer to the difficulty of making up any hard-and-fast rules about what a drawing is. It would prove just as difficult to try to define drawing in terms of subject matter.

This book deals with representational drawing. Representational drawing is not about techniques or media, as many books seem to suggest. Although technique and medium are important, the problems most beginners have when they try to create a representational drawing are not to do with choosing the wrong pencil or the wrong ink. Drawing is about seeing in a particular way which allows for the translation of the three-dimensional world being observed into a two-dimensional form on a plane surface. There are many ways of representing what we see in the form of drawing, and each of these approaches obeys a certain logic. The traditional cultures of the Far East, for example, use a system of representation which is different but just as logical as the Western European system. This book, however,

deals mainly with the picture-plane representational European system, which has been the predominant pictorial form since the late 15th century. Although other cultures are mentioned in the text, they are not discussed in any great detail.

Most of the visual images we see in our everyday lives, – such as on television, as magazine pictures, on the cinema screen etc – we see through the picture-plane system, and it is often forgotten that this approach to representing the world has not always dominated our perception, nor was it invented and developed by one single person, but by artists during the Renaissance over a period of approximately one hundred years. It is now so universally accepted that it is difficult for many people to imagine any other system of creating images.

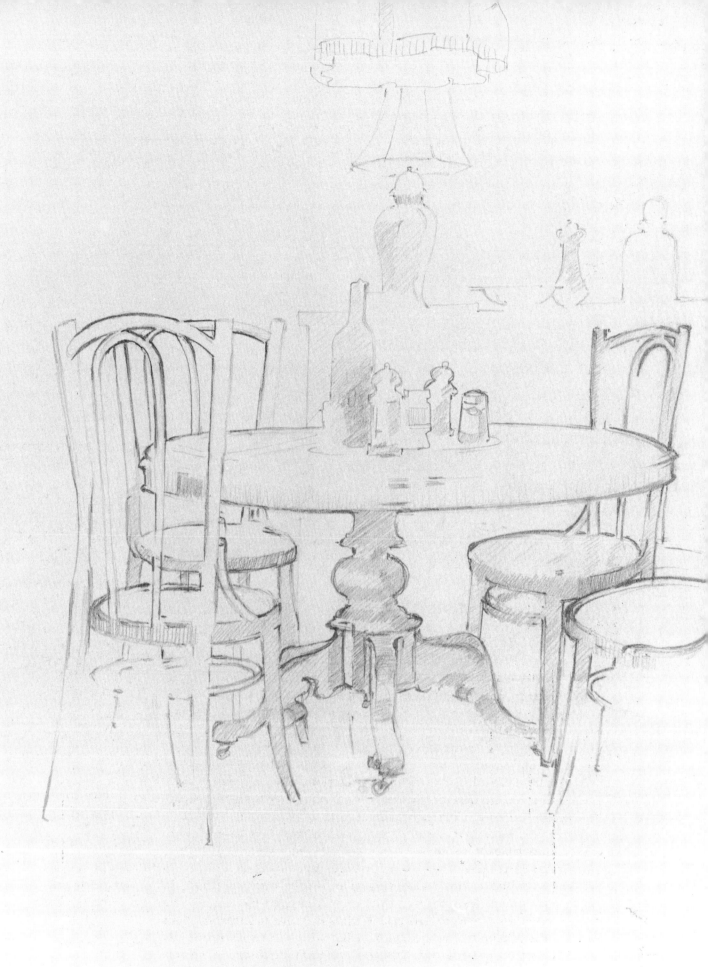

PERCEPTION

LEFT Pencil representational drawing of a dining room table and chairs.

Y OU MIGHT THINK it odd that the first thing it is suggested you do in a book about drawing is to write something, but it is essential to be aware of how we use our eyes in the everyday business of conducting our lives, and to discover what adjustments we have to make to our perceptual processes to successfully make representational drawings.

As an exercise, perhaps at the end of an evening meal, leave the dining table and walk into the adjoining room. Write a full description of the table in the room you have just left. It will probably contain the following sort of information. 'There are four dinner-plates on the table, knives and forks, water-jug, coffee cups, drinking glasses. The table is a round, mahogany table.' This first description will probably be quite limited, constructed almost as a list enumerating the various items you can remember.

Now return to the room you were in. Sit looking at the table in front of you, and write another description. You will probably once again begin by making a list of objects, but you may well discover there are quite a few things that you had left out. Your second description of the objects will now probably be much more elaborate and individually detailed, one or two favourite objects being singled out for particular attention. The table itself, for example, might be described as an early Victorian, round, mahogany table with ornate central pillar and carved tripod legs on small castors. You might also begin to describe your reasons for any particular attachment to this table. You might then likewise choose to describe in much greater detail the salt and pepper mills, how you came into possession of them, and any story attached to them.

The reason for suggesting that you carry out both of these descriptions is simply to make you use your eyes. You were first asked to stretch your memory, and you may have been quite surprised at how many things you had forgotten to include in your first description. In the second attempt you consciously used your eyes to gather considerably more information than your memory could hold. You should by now have proved to your own satisfaction that you are quite an observant person

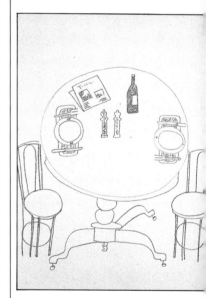

ABOVE This pencil drawing was obviously done from memory by an untutored eye. It is an attempt to make a representation as in the previous illustration opposite. Without the table in front of you it is very difficult to remember the relationships among the objects to be drawn. Many things are left out, and things have been added that were not actually there.

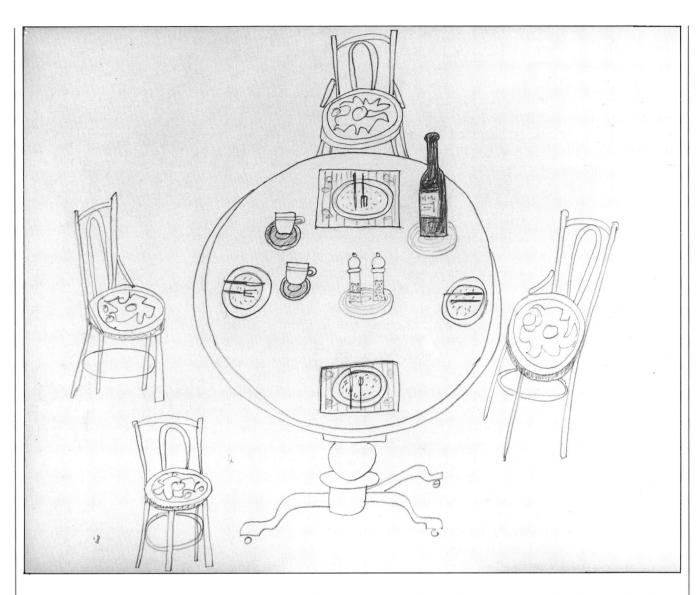

ABOVE *A pencil drawing of the same subject matter. Here however, the drawing was made with the table and chairs in full view. Again, little attempt has been made to render the drawing with any perspective, although all the objects are recorded more tellingly, with the patterns on the plates, the chair seats, and indication that the bottle and saucers are of a darker colour. There is clearly far more information in this drawing.*

You can see from these two photographs that they have been taken from different angles. In the untutored drawing the student has attempted to incorporate in one drawing the information gathered from view points which are unrelated. It is obvious that the photographs are of the same table, but the visual information they contain is very different. This is even more apparent when the two photographs are transformed into two line drawings (below).

and quite capable of assimilating in considerable detail what is visually presented to you, but that you find it much harder to reproduce it all from memory.

A problem arises, however, when you try to translate this method of observation into a drawing. Leaving the objects exactly where they are on the table, make a drawing of the room in front of you. You will probably end up with a drawing not dissimilar to the one illustrated. Most beginners find it exceedingly difficult to draw a table from wherever they are viewing it. It is impossible to see it as a complete circle, and there is a strong compulsion to visually tilt the surface so that all the objects you wish to draw can be clearly seen. This is due not to any lack of ability to see, but to using the information seen in a way that is not compatible with the act of drawing, but that corresponds completely with the act of verbal description. For example, to

verbally describe all the objects on the table it is necessary to visually isolate them one by one, find an appropriate word or sentence, and move on to the next object. In your first drawing most beginners still want to use the visual information in a verbal way. One reason for wanting to tip the table is a wish to separate each object so that an individual descriptive drawing can be made of it. In exactly the same way, your written description enumerated the objects on the table.

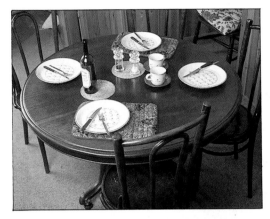

Now try again to draw the table. Place a chair about eight or ten feet away, sit down and try to draw the objects on the table from this one fixed viewpoint. It soon becomes apparent that not all the objects on the table can be fully seen. One object may partly obscure another, and a proportion of the whole table may be partly obscured by a chair that is in your line of vision. You will probably still find an urge to visually tilt the table at a far greater angle than it actually is. You will also probably find that you tend to draw one object first in its entirety, then move on to the next, and so on, and that you try to fit the table and chairs round the objects.

This exercise will have been much more difficult than you imagined at first it would be. There is absolutely nothing wrong with your eyes, nor with the visual information that you are receiving. The problem is that you have not been using the information in a genuinely pictorial way.

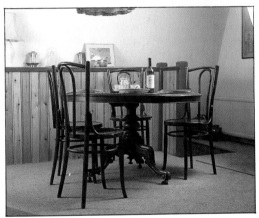

The main problem most beginners have in perceiving the interrelationship of all the objects is thus due in some degree to the fact that they tend to perceive the world in a solely three-dimensional way. To fully appraise most objects it is normal to pick them up or walk round them, using your eyes all the time to take in details of colour, form, weight and texture. It is not until beginners actually start to make a representational drawing of what he or she sees from a fixed viewpoint that the full realization occurs that it is impossible to see an object in its entirety. For example, if you were to move the chair on which you sat to do your first drawing just one foot to the right or to the left, all the visual relationships of the objects on the table – such as the spaces between them and the shapes of the objects themselves – change. From your first position you might for instance have been able to see a cup; you knew the handle was there, but you could not see it. From your second position, the cup has not moved, but you can now see the handle. Pictorially the object has changed its shape. What beginners are always fighting against when they first start to draw is their *perceived experience* of an object as distinct from their actual view of the object.

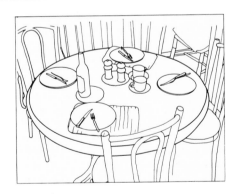

We all receive through our eyes far more information than can possibly be represented in a single representational drawing. We therefore have to be selective, using only the visual information that can be recorded from a fixed viewpoint.

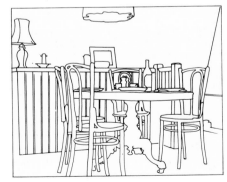

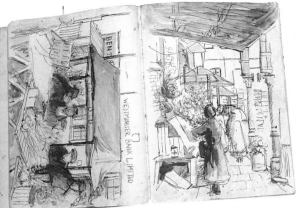

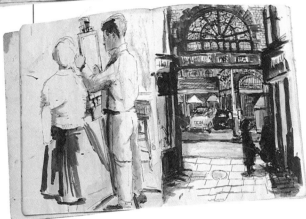

ABOVE *Sketchbook studies; it is no hardship to take your sketchbook with you, practically wherever you go. It will provide excellent practice in developing your visual awareness and a valuable source of material for more finished works developed later. Are these sketches complete? That is, of course, up to the artist.*

From these examples it is evident that when we use our eyes normally we are gathering too much visual information, not all of which can be included in a representational drawing. Always remember the art of drawing is to see from one fixed viewpoint and to select from the visual information what is most useful to create a pictorial representation. Drawing is not about seeing better, but about being more selective. You cannot draw unless you ask your eyes and your mind the right questions.

The exercises in this book are designed to help you to start asking yourself the right questions, through your eyes. Each suggested exercise on its own is comparatively simple and should not cause any great difficulty. The art of representational drawing is to utilize the whole or part of these individual exercises at the same time, because a drawing is a combination of all the elements described. Learn by the experience of drawing from life. Do not expect to be able to comprehend all the aspects of drawing at once from the beginning.

In this book there are outlines of several theories normally associated with representational drawing – such as perspective, light and shade, tone, etc – but try to avoid learning these theories in isolation. For example, familiarize yourself with perspective by working on a subject matter that requires some basic knowledge of the subject, such as drawing buildings. When you begin, try to avoid working from photographs or other drawings because in these the three-dimensional world has already been translated into two-dimensional – ie flat-form. The main purpose behind this book is to help you to translate the three-dimensional world you see, by using your eyes, into a two-dimensional or flat (plane) form. Although drawing from photographs might give you a satisfying result, it cannot help you in the true quest of learning how to see in a pictorial way. Photography can be very useful – but leave it until you have practised some of the exercises. Practice and first-hand experience are the finest teachers – theories are useful if kept in their place. You already possess all that is required to draw.

This book concentrates on the form of representational drawing predominantly associated with Western culture, although that is not the only method of representing the three-dimensional world in a flat two-dimensional way. The visual conventions of pre-Renaissance culture and of Eastern cultures are different. Even in our own culture, conventions are different in certain aspects of design – for engineers and architects, for example, who make very accurate and easily understood drawings of three-dimensional objects which do not obey any of the conventions of representational drawing. This book deals primarily with the post-Renaissance conventions governing representational drawing, however, and makes no attempt to investigate other methods in any depth.

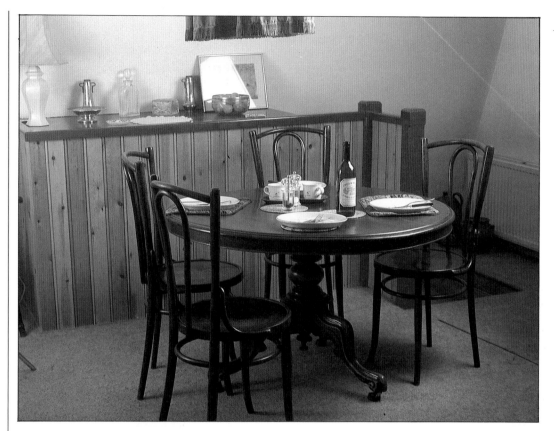

A casual glance at these two photographs tells us that they are the same, and many people, even if challenged, would insist that they are identical. They would define the photographs by the subject matter. Viewed pictorially, however, they are quite different. The objects are in a different relationship, not only to each other, but also to the edges of the picture plane: consider, for example, the changed relative positions of the bottle and the middle chair. Produce your own line drawings of both of these photographs, as on page 15, together with detail drawings of the central section.

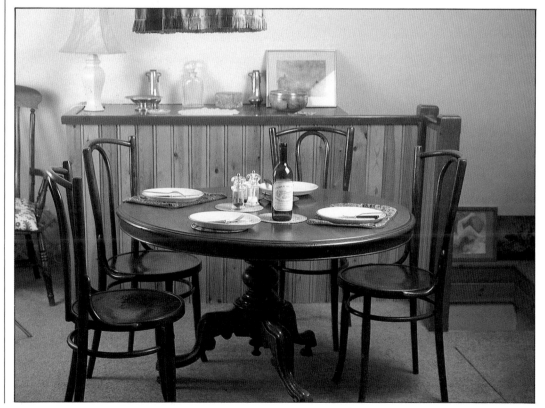

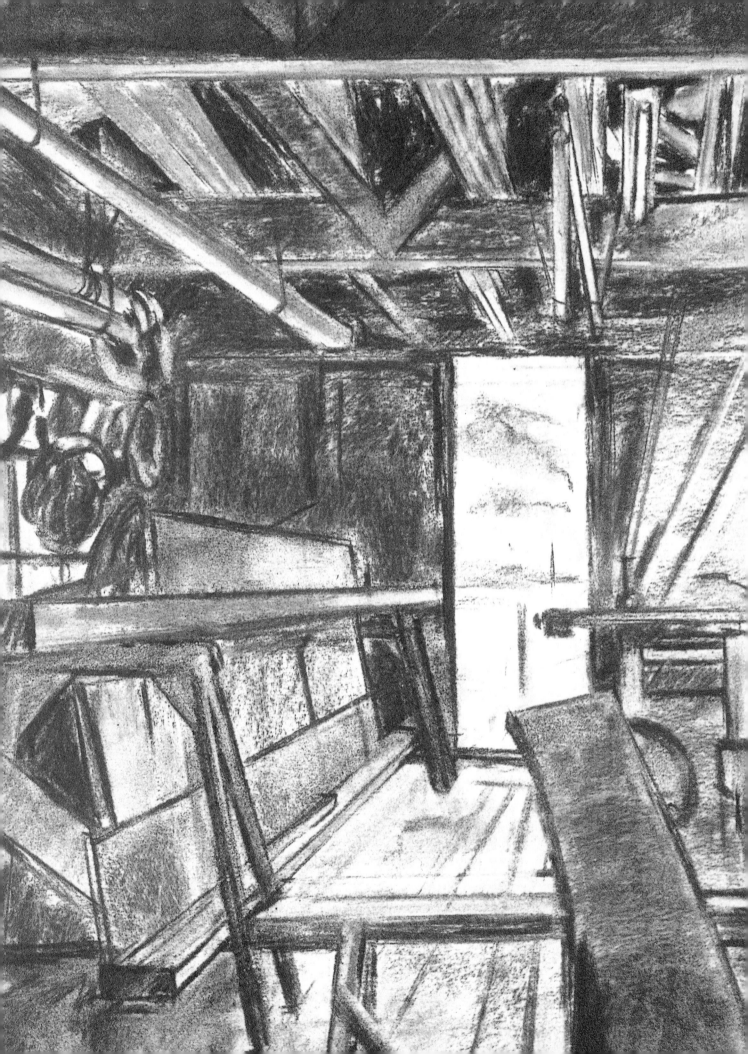

BASIC PRACTICE

LEFT The concept of the picture plane is very clearly demonstrated in this drawing. We are looking down the length of a shipwright's shed, and the enclosed space of the walls and ceiling creates a box; the end wall with a door is parallel to the picture plane. The door opening is in itself a secondary picture plane to the scene outside.

In the accompanying diagrammatic drawing (above right) the parallel relationship of walls, beams, etc. to the picture plane, can be more clearly seen, as can the eye level and vanishing point. Even in a drawing which has the appearance of being quite freely and loosely rendered, on closer inspection reveals its perspective understructure.

RIGHT In this drawing the student has drawn the boxes as they would normally be conceived: showing five individual objects and their relationship to one another. The table has almost been disregarded, conceived as of secondary importance. The drawing is descriptive but not visually representational.

*O*NE GREAT ADVANTAGE of drawing is that there is no need for a lavish studio or even a room set aside for it, and the equipment used can be of the most simple type. Some of the most beautiful drawings have been done with a piece of burnt stick and coloured earths on cave walls. The right pencils, the right ink and a perfect easel cannot in themselves make anyone draw any better. There is only one requirement: to see.

Collect together four or five cardboard cartons of various sizes, and a couple of bottles, and place them in a natural way on a table that itself should preferably be rectangular. Put your paper on a piece of board and sit on a chair with another chair facing you, propping the board up on that chair, so that it becomes an easel. There is a good reason in this exercise for this odd way of sitting. Look carefully at what is in front of you and try to draw the cartons on the table as accurately as possible from the fixed viewpoint you have chosen.

At your first attempt you will almost certainly come up against the problem mentioned in the previous chapter. Your mind, through your previous experience of cartons, knows that they have got sides, tops and bottoms and will not believe what your eyes are now telling you – that the tops of the cartons do not appear as perfect rectangles. Even though you are looking across the top of the cartons and your eye is giving you that information, in your mind will try to tilt them up so that their squareness or rectangularity can be fully seen.

Try a second drawing. This time, do not look at the cartons individually as boxes but run a line with your pencil from where you have drawn the edge of the table around the shape of all the boxes, making a single outline shape. Your first drawing may well have got into difficulties because your mind was telling you that the boxes were all individual and separate objects, and you were trying to draw one, then another, hoping they would all relate to each other in the particular arrangement in front of you. The eye is also seeing them as individual boxes. In your second drawing you are attempting to see them as a whole shape, not individually. You have now taken the first step to translating what is three-dimensional form into two-dimensional form.

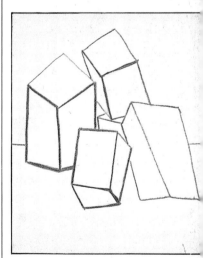

To artists such as Uccello and Michelangelo, the mysteries of proportion and perspective were studied in a logical and scientific manner. The Renaissance totally re-evaluated the concepts of representational art, and most artists of the period experimented with drawing through a grid screen to understand how the proportions of the same object alter radically from different view points. We are now so familiar with seeing pictures – both photographic and drawn – that it is often difficult for the beginner to believe that this particular approach to drawing has only recently been universally accepted as a representation of the world.

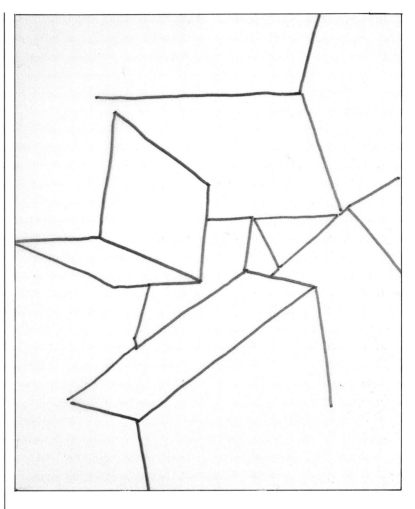

LEFT *The second stage in the drawing, after the simple silhouette* BELOW. *It is a careful observation of the centre, where all the boxes make a negative shape relative to one another. This is drawn in the correct proportion and relationship to the outer line drawing.*

ABOVE *In this simple line drawing the five cartons have not been seen as individual shapes but have been approached, along with the table, as a flat silhouette, creating a two-dimensional pattern on the paper. It is impossible to make a drawing like this without conceiving of the cartons as one total shape.*

Now move the boxes around into a different pattern, making sure that there is a gap between one or two of the boxes. Again draw purely linearly, starting from where you draw the edge of the table. When you come to the gap between two boxes, try to become aware not of the next box but of the negative space between the boxes. In your two-dimensional translation, the negative space is just as important a shape on the paper as the positive shape of the box itself. You are translating this third image into a series of flat patterns on a flat surface.

Think of your sheet of paper as a flat sheet of glass through which you are viewing the boxes. This can be very useful in helping to understand the two-dimensional nature of drawing. If you can obtain a piece of glass or a sheet of clear, stiff plastic, mask off an area as illustrated, the same size as the piece of paper on which you are going to draw. Prop up the piece of glass in front of you so that the boxes are viewed through this glass screen. With a felt-tip pen start marking out the form of the boxes on the glass screen. You will then see how the eye transposes the boxes into a two-dimensional surface – the glass

1 Use a piece of normal window glass or a piece of rigid PVC plastic, approximately 14 × 20in (35 × 50cm). Tape off an area 12 × 16in (30 × 40cm). Cut two slits of equal depth with a saw in two short lengths of 1 × 2in (2.5 × 5cm) timber.

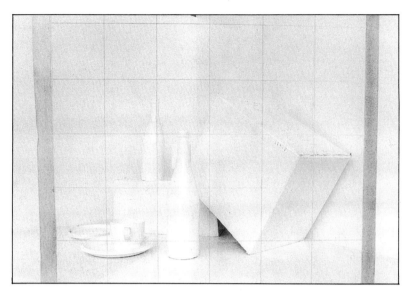

RIGHT *This is undoubtedly a drawing of five cartons, but the visual approach to this drawing, and the way in which the cartons are seen, are very different to the first attempt on page 19. Here, the boxes appear to be in the correct size and relationship to one another, as you would expect in a representational drawing. The boxes were seen quite clearly in the first drawing, but the information was used in a haphazard way. In this image, the observation has been ordered in a way which makes representational drawing possible.*

2 Draw the objects onto the glass screen using a felt tip pen or fine brush with a little gouache, making sure that your corners used as a reference are correctly in line each time you make a mark.

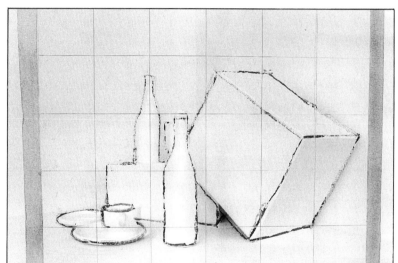

3 Square up your glass screen into a 2in (5cm) grid. Square up your paper into a 2in (5cm) grid. Your paper and your grid are now exactly the same size and identically squared up.
4 Sit so that you can see through the screen and look at your paper without having to move. Note where the objects in your still life are positioned on the grid and draw accordingly.

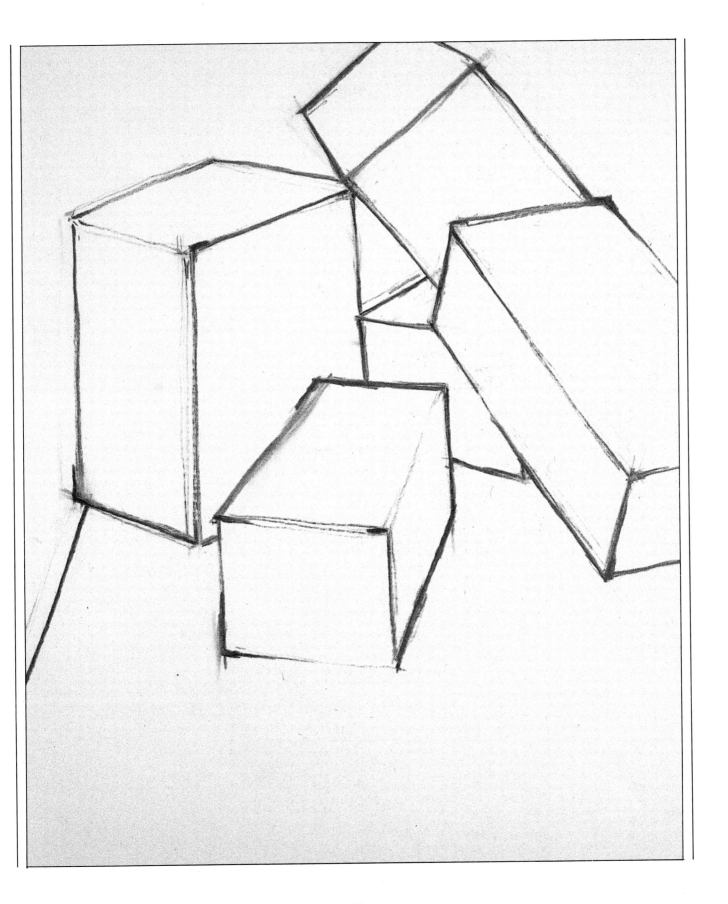

Beach at Trouville by Claude Monet (1840 – 1926) is a good example of a well-constructed design with a feeling of inevitability. It is not surprising to find therefore, that the major compositional lines fall close to the Golden Sections. But, from what we know of Monet's methods, it is unlikely that he used mathematical means to locate the proportional divisions. Through a combination of training, and an instinctive visual sensitivity, he has achieved a happy balance, while retaining the vigour so characteristic of his work.

The Golden Section (formulated in Vitruvius' De Architectura in the first century BC) was the basis of the Greek definition of perfect proportion. Vitruvius stated that a harmonious relationship was achieved between unequal parts of a whole, if the smaller was in the same proportion to the larger as the larger was to the whole.

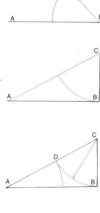

To construct a rectangle in the proportions of the Golden Section, divide the line AB into two sections of equal length. From B draw an arc from the midpoint of AB to C at right angles to AB. Draw in CB and CA. Then from C draw an arc with radius CB to cut AC at D. From A draw an arc with radius AD to cut AB at E. In proportion EB is to AE as AE is to AB. A rectangle can now be drawn.

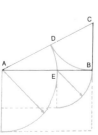

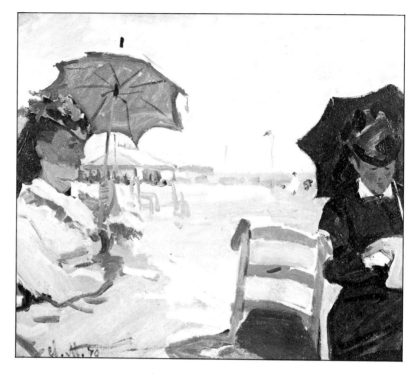

screen. You will also realize how important a fixed viewpoint is in representational drawing. The slightest movement of the head alters all the relationships between the boxes that you have already drawn on the glass.

In this exercise you might find it easier to close one eye when drawing. Put a mark representing the most obvious corner of the nearest box. Before you make another mark, always make sure that the first mark you made is correctly aligned with the corner of the box that it represents on your glass screen. This ensures that when you make further marks on the screen they are in the correct relationship one to another.

You may well be wondering why you were asked to prop a board up on a chair and draw in that particular manner. The sheet of glass or plastic is acting as a transparent picture-plane. A picture can be thought of as a rectangular surface through which we see the world. This window we call the 'picture-plane' and it is the most important concept to understand in representational drawing. How does this glass picture-plane through which we are viewing the boxes relate to our drawing paper?

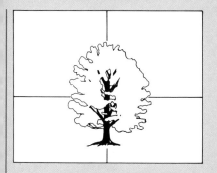
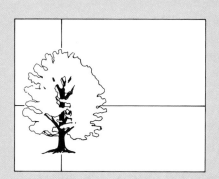
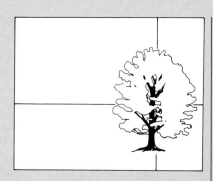

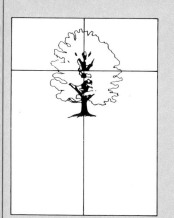
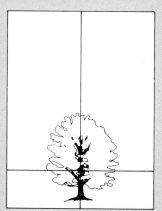
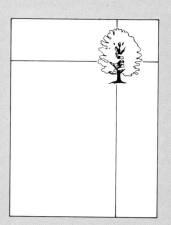

As the tree, which is identical, is moved to different positions on the picture plane, the composition of the picture is radically changed. Although it is an identical drawing in each case, the composition of each example is quite different, thus illustrating the fact that although the subject matter can be important in making an interesting drawing, it is not necessarily the most important. It is more important that the position of the subject matter within the four sides of the picture plane will make an interesting composition.

Rearrange the boxes again and prop up the sheet of glass or plastic as shown. This time, however, notice that on the glass there has been ruled a square grid producing 2-inch squares right across the whole viewing area. Rule up a piece of paper in the same 2-inch squares. Repeat the procedure of looking through the glass screen and note where the significant lines of the boxes – the corners, etc – are in relation to the grid on the glass screen. Find the corresponding position on your squared-up paper and mark it accordingly. When you have positioned all the most important marks – representing the corners of boxes, the distances between boxes, the angle between one box and another, the distance from the edge of the cartons to the edge of the table, the location of the front edge and the back edge of the table – remove the glass screen and continue to finish the drawing from the established marks.

With patience you will eventually complete a drawing quite accurately of the boxes in front of you.

Whenever you make a representational drawing, whether you are attempting a landscape, a figure, or any other subject, your mental and visual processes should correspond to thinking of it as drawing through an imaginary picture-plane, or as through a real picture-plane which you have just physically removed by taking away the glass sheet. The nearer you can get your piece of paper and board to a vertical position, the easier it is to relate this imaginary glass picture-plane to your paper.

Representational drawing is viewing the world through a window. As another exercise look through a window in your office, work place or home, and draw on the window with a felt-tip pen the landscape or townscape that you can see.

The fundamental difference between representational drawing and all the other forms of drawing is that the subject matter to be drawn is viewed as through a vertical window on the world. An analytical investigation of this particular approach to drawing was undertaken in the Renaissance by such great masters as Paolo Uccello, Leonardo da Vinci, and many others, and it represented a fundamental change in the way in which painting and drawing was practised from then on.

In the Western world, the picture-plane – ie representational drawing – was not seriously challenged as a concept from the 15th to the 20th century. Inseparably linked with the concept of the picture-plane, and subservient to it, are the theoretical concepts of composition and linear perspective. These concepts are often incorrectly studied as separate subjects.

Composition is the overall relation of the objects being drawn to the edges of the picture-plane. In the several illustrations of the same tree given as examples (on page 25), it can be seen that the positive and negative shapes – ie pattern – that make up the composition are radically altered by the position of the tree rela-

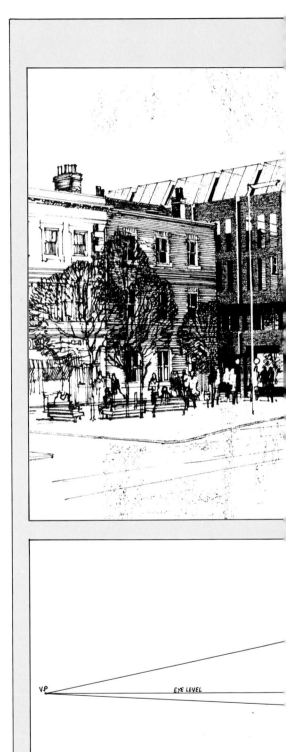

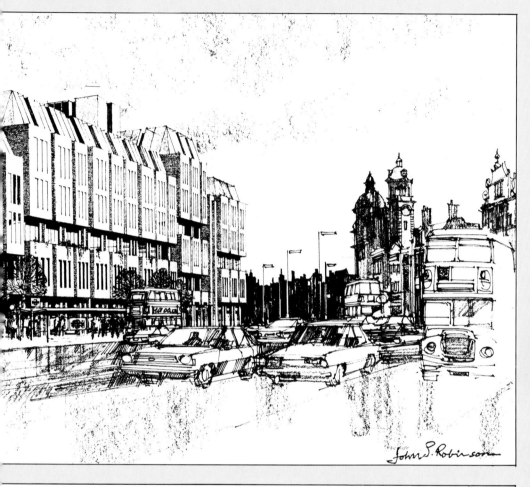

LEFT *This perspective rendering of an urban development is a fine example of the architect's use of two point perspective for visualising a proposed development in an existing urban street. The pedestrians and motor vehicles are used in this case to give the drawing a sense of relative scale. A visual device is used to make the pedestrians and motor vehicles slightly smaller than they would actually be to give the proposed building a grander sense of scale. If the opposite effect is required, the pedestrians and vehicles would be drawn larger, therefore reducing the apparent size of the building.*

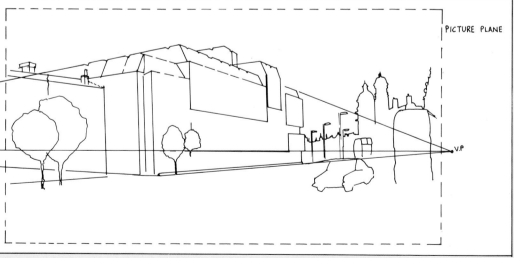

PICTURE PLANE

V.P

RIGHT *This pencil study of a sweet jar concentrates on the reflections in the glass, but the basic drawing is no more complicated than the basic study of the boxes.*

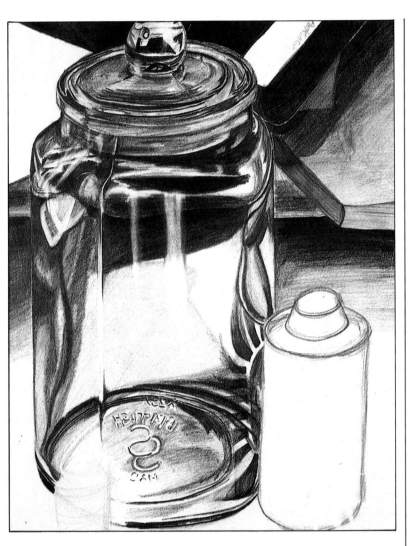

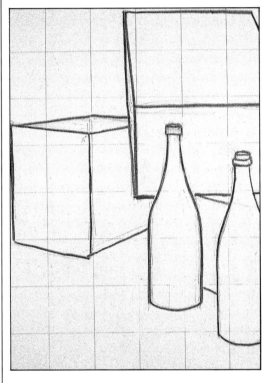

ABOVE *If the corner chosen to align the drawing – marked 'A' – has been correctly positioned, you should be able to achieve a result with a reasonable amount of accuracy.*

tive to the edges that make up the picture-plane. If the tree is placed centrally and the picture-plane has horizontal format, there are three equal distributions of pattern: from left to right, negative space, approximately equal positive space, approximately equal negative space. By moving the tree to the left or right this relationship in the proportions of the pattern is altered, thereby giving an entirely different 'feel' to the drawing.

In addition to a relationship between the positive and negative spaces on a horizontal plane (from left to right), there is also a relationship from top to bottom. Take the same tree and place it on a picture-plane that is now vertical in format: the balance of the positive and negative spaces from left to right and from top to bottom again are radically different. Yet each composition contains an identical drawing of the identical tree.

In general, it does not matter how well you draw a tree if the composition of which it is a major part is boring and very equally balanced. A less well drawn tree that divides the picture plane

into a greater variety of more interesting shapes may be a much more exciting piece of work.

Scale and perspective are really the same thing. Perspective is often thought of, incorrectly, as the mathematical theory much used by architects to render a three-dimensional visualization of a proposed building project. This mathematical theory is indeed one form of perspective which is dealt with more thoroughly at a later stage in this book, but linear perspective is only a mathematical device to be able to work out in a logical manner the relative size of objects as they recede into the distance. For the artist, accurate observation of the relative sizes of objects already deals with most of the problems of perspective and scale. Mechanical perspective is often used by beginners because their perception of scale needs the prop of an authoritative theory to convince them that what they are seeing is correct.

This is something that has already been discussed. You know that all the cows in a field are more or less the same size. The problem you have with drawing them in scale – that is, so that the ones furthest away are the smallest – is that your pre-knowledge tells you that they are the same size. The reverse can also happen. You know a stand of bulrushes in the foreground are much smaller than the cow in the adjacent field but, try as you may, you find it difficult to believe that visually three-quarters of a cow can be obscured from your view by one single bulrush. Your mind tells you to draw the cow bigger. With accurate observation you should be able to believe the visual information that your eyes are receiving. Perspective is a sense of scale, or the size of an object relative to other objects on the picture-plane, and their size relative to the size of the picture-plane.

To return to the drawing of the tree in our example, the tree is always the same size, what has altered, however, is the size of the picture-plane (piece of paper) on which it is drawn. In the first example the size of the picture-plane has been reduced, and the tree looks exceedingly large. In the next example the size of the picture-plane has been increased, and the tree looks as though it is in the middle distance. In the third example the drawing is on an altogether much larger piece of paper, and our initial perception is that the tree is in the distance. Scale is thus not about actual size; it is about relative size.

Both perspective and composition, in conjunction with the picture-plane, are constantly referred to throughout this book, each time relating these very fundamental aspects to the particular subject matter. The way in which perspective, for example, is used in drawing the figure, in landscape and still life is fundamentally the same, but has a particular application relative to each of those subjects. This applies equally to the theory of composition. The concept of the picture-plane in representational drawing stays constant whatever the subject matter.

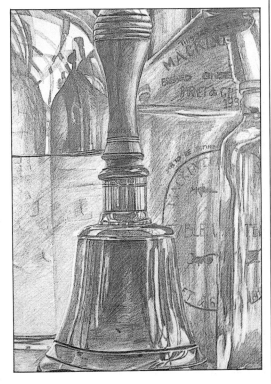

ABOVE *In this pencil study of a hand bell the reflections in the mirror and glass jars echo and reflect the metallic polished surface of the bell.*

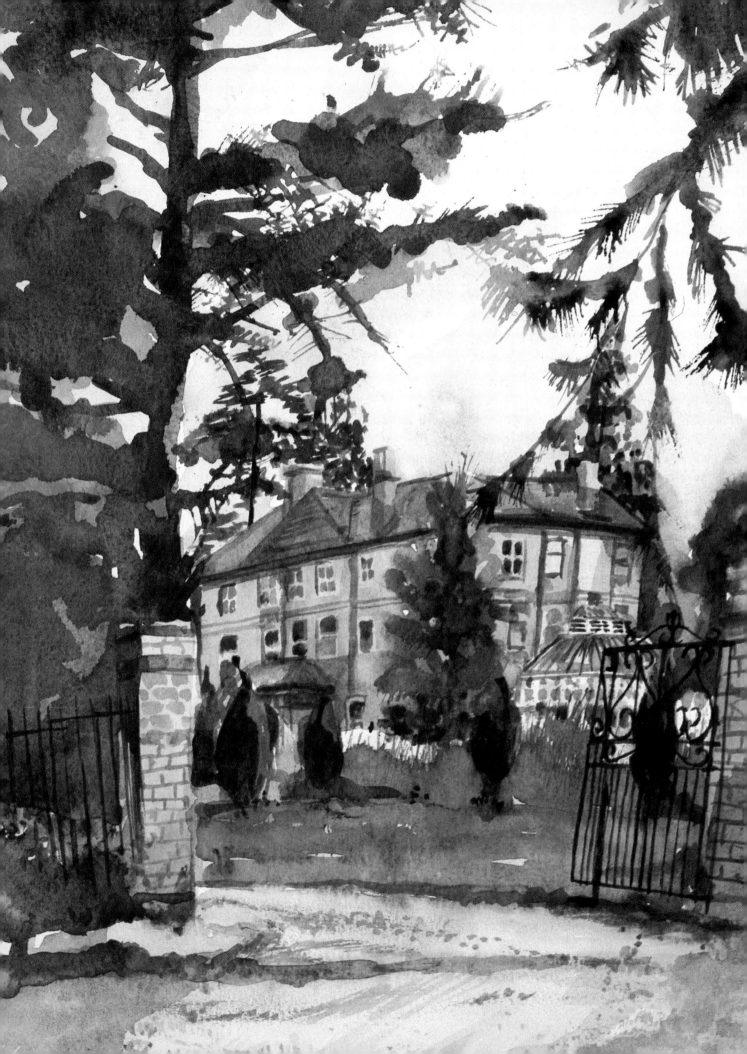

CHAPTER THREE

LANDSCAPE

*L*ANDSCAPE is the preferred subject matter as a first intro-
duction to painting and drawing. This is very understand-
able because it combines so many pleasures. There is not only
practice in drawing but there is the added delight of being in the
countryside 'communing with nature'. Landscape as subject
matter is less exacting for the beginner than say, portraiture,
and a pleasing and satisfying result can be achieved quite early
on. These successes should add greatly to the beginner's self-
confidence and enable him or her to tackle more complex sub-
jects in a less tentative way.

In Europe there is a long tradition of landscape painting and
drawing, although it became recognized as an independent art
form in the 17th century. Before that time most landscapes were
backgrounds in compositions where figures or groups of figures
played the most important role. The evolution of the landscape
as an independent art form did not happen overnight, more-
over, but developed from paintings often depicting a group of
figures in an idyllic pastoral setting with Greek temples, castles,
or ruins, setting the scene firmly in an Arcadian past.

The kind of painting now recognized immediately in a modern
sense as landscape art is a northern European innovation
practised in particular by a 17th-century Dutch school of artists.
In these paintings the subject matter is contemporary with the
time the painting or drawing was made. It is not an idealized
landscape. It is one in which the clouds can rain and the sun can
be scorching hot; a landscape that is instantly recognizable today
even though such pictures were painted three hundred or more
years ago. This style and attitude towards landscape painting
has been kept alive particularly in Britain, the US and the rest of
the English-speaking world and elsewhere in Europe by a suc-
cession of artists throughout the generations to the present day.

Two of the most revered exponents of landscape painting,
John Constable and J.M.W. Turner, are familiar names to many
people whether they have any interest in art or not. Almost
everybody has heard of them. The present day view of Con-
stable's work is somewhat different from the view he himself
and his contemporaries held. We tend to see these artists' works

*LEFT A study in pencil and
watercolour wash; here the
brush has been used with
great skill as a drawing
instrument.*

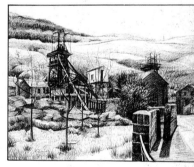

*TOP A detailed sketch-book
study of a pine tree; the
hatching describes the spiny
foliage very effectively.*

*ABOVE A mine in winter:
pencil and conte. The
angularity of the machinery
is complemented by the
clarity and detail of the trees
and wall.*

as representations of a countryside pictured in an idyllic past. To Constable and his contemporaries they were a view of rural life as it actually was in the 18th century and early 19th century. There is a tendency among amateur artists now to look for similar subject matter – for example, thatched cottages and water mills – and to leave out of their paintings any modern intrusion, such as power cables, tractors and vapour trails from jet aircraft. Such features are excluded often in the misguided notion that Constable would not have put them in. Obviously he could not because they were not there in his day. If they had been, both Constable and Turner would have included them in their paintings as they would have been an integral part of the contemporary landscape – and legitimate subject matter.

Imagine the discussion and argument that the building of a railway viaduct must have caused among those used to horse-drawn transport in Victorian rural England. 'Such brick monstrosities are a blot on the landscape!' Yet Turner, very much a painter of his contemporary world, willingly included them in

RIGHT *The Venetian painter, Titian, is not known to have painted an independent landscape, and in this painting, 'Sacred and Profane Love'(1516) we have a typical example of how landscapes were used as backdrops to the main subjects. If these landscapes are looked at independently it will be seen that they are a well observed study from nature, but they cannot be considered as independent paintings. During the Renaissance the landscapes in the backgrounds of paintings were often used to show scenes of secular life. On the lefthand side of this painting a rider at full gallop at sunset is hoping to reach the town before nightfall and curfew. On the righthand side, two horsemen are engaged in a hunt and a shepherd is gathering his sheep ready for the night vigil. These two landscapes are not celebrations of nature, but are used as a setting for human activities.*

ABOVE RIGHT *In this charcoal study, both linear and atmospheric perspective are incorporated. The linear perspective of the ruts in the track is reinforced by the line of the secondary growth of the hedge on the left. The lightening of tones from the foreground to the background – atmospheric perspective – is quite obvious.*

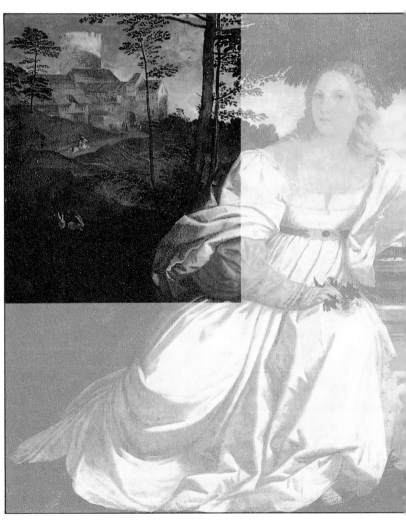

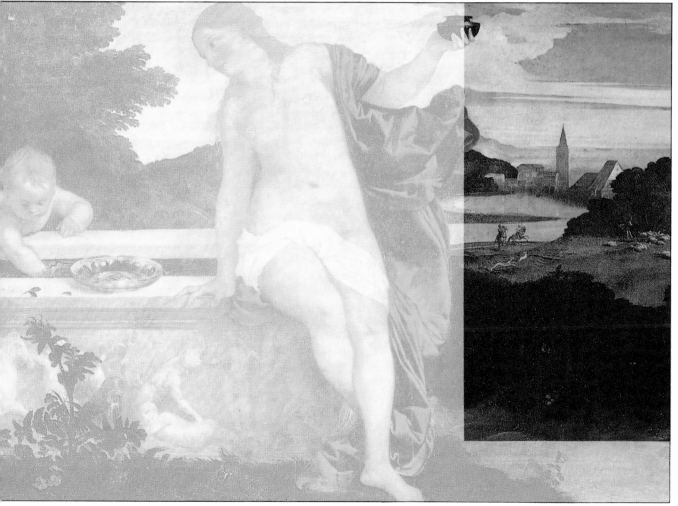

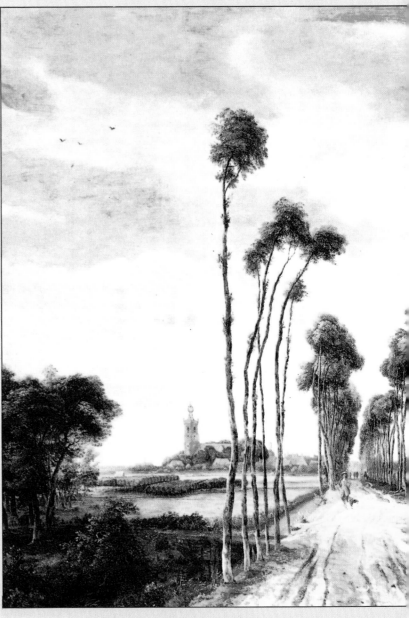

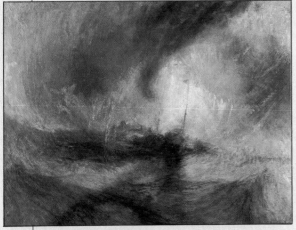

TOP *A free and direct study in pencil and chalk; the wild tangle of the trees is built up using chalk, and the firmer lines are made with a hard pencil. The lack of careful delineation makes the scene enticing, leading the eye to the doorway.*

ABOVE *Turner, a near contemporary of Constable, approached landscape in a more violent and romantic way. Many of Turner's canvasses depict the puniness of man when nature unleashes its full power, and the example illustrated,* The Snowstorm *(1842), shows a product of then modern technology, the steamboat, being tossed in the storm like a leaf in a gust of wind. The sky and the sea have become one spiralling vortex of natural forces. This subject matter was a recurring theme in paintings of Turner's mature period.*

ABOVE *This late 17th-century Dutch landscape by Meindert Hobbema,* The Avenue at Middelharnis *is an example of a fully independent landscape painting. There is no suggestion of any mythological story and the painting can be seen as a representation of the secular life of a 17th century Dutch village. The figures are ordinary people going about their everyday tasks, walking their dogs and tending their gardens. The symmetrical composition created by the dykes and the uniformity of the parallel avenue of trees make this a clearly man-made landscape.*

BELOW *This mid 17th-century Dutch painting,* **Wheatfields Landscape** *by Jacob Van Ruisdael, is very typical of the Northern European school and it is full of the realism that caused Dutch painters in particular to have a great influence on future generations of landscape painters. Jacob Van Ruisdael is said never to have painted on a clear day and he was a master of drawing and painting dramatic cloud formations. He delighted in the contrast of those areas in the shade of the clouds and the brilliance of those parts of the scene that were in full sunlight.*

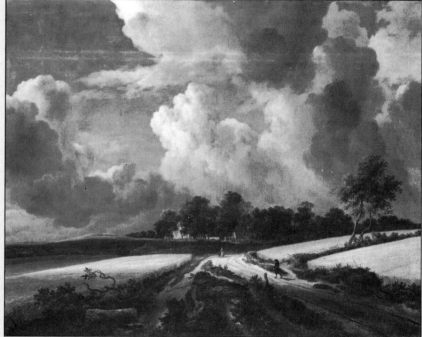

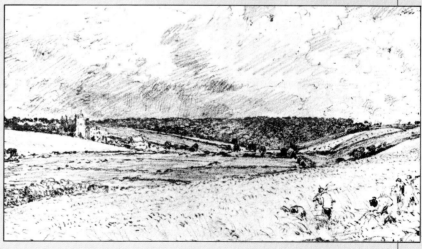

RIGHT *John Constable's* View of Wivenhoe Park; *this sketch in pencil succeeds in giving the cornfield in the foreground its own character with the lightest of touches, and the casual, individual pencil strokes which evoke the gathering clouds can be easily seen. What the artist has not done – that is, the white of the paper – is as important as what he has done.*

ABOVE RIGHT *If you intend to take a drawing to a finished state it is most useful to have a sketching stool and easel. Although not absolutely essential, it is more comfortable. Position yourself in such a way that you can see that part of the landscape that you wish to draw, also your drawing, without moving your head too much. You are looking at a landscape through an* imaginary picture plane *which you are then transposing onto paper. Try to avoid having direct sunlight on your paper, as the glare can be very tiring on the eyes.*

his great range of subjects, and through his acceptance of these new phenomena in the landscape in such paintings as *Rain, Steam and Speed,* and *Snowstorm,* he made these modern features perfectly acceptable as subject matter for great art.

It is not necessary to live in an area of outstanding natural beauty to successfully produce a landscape drawing. There are numerous examples of interesting paintings and drawings of industrial canals, gas and petroleum plants, major road flyovers and suburban back gardens. Try to draw those things that are familiar to you and are around you. By working in your immediate environment you will make a drawing which in its own way will be as relevant an observation of our world as Constable and

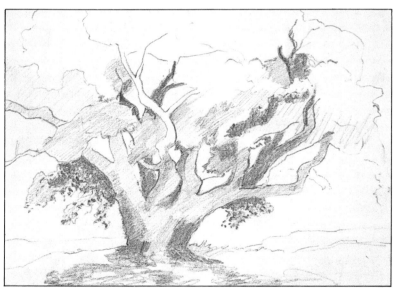

LEFT *Drawing an oak tree: this drawing shows the completed first statement. All the major elements of the landscape are entered, and the structure of the composition has been decided within the designated picture plane. Every effort should be made to get to this stage without a break. Do not keep stopping, standing back and considering what you have done. If you do, you will lose the overall feeling of the drawing, and there is a tendency for beginners to change their original intention and get involved in a detail.*

BELOW LEFT *You can now see large areas that are in shadow in this drawing. They have been altered and very lightly cross-hatched, and already the form of the trees and buildings are beginning to take shape as three-dimensional objects. Notice this has been carried out right across the whole drawing. Again it should be stressed, do try and avoid concentrating too heavily on one particular area. If the drawing is going to be used as the basis for a watercolour painting to be completed when you return home you probably have sufficient information.*

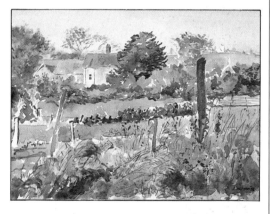

ABOVE *A beginner's attempt at watercolour by the direct method. This entails no preparatory drawing and therefore great skill and confidence are required to work directly with the brush. This example has become slightly confused, and under normal circumstances it is recommended that the beginner makes preparatory drawings.*

Turner made of theirs. Try not to leave out those things in the scene that do not fit your notion of the perfect landscape. A drawing of a stand of trees flanking the drive of an inner-city park drawn without the high-rise buildings, lampposts and other street furniture says less about our contemporary landscape than if they were included.

This attitude should also be applied in the countryside. It is extremely rare to find a farmyard which has an old barn that has not had built adjacent to it a modern concrete and asbestos pig unit or tractor shed. The machinery about the yard will not be a handcrafted wooden hay wain but more likely a construction in bright red tubular steel with fat rubber tyres.

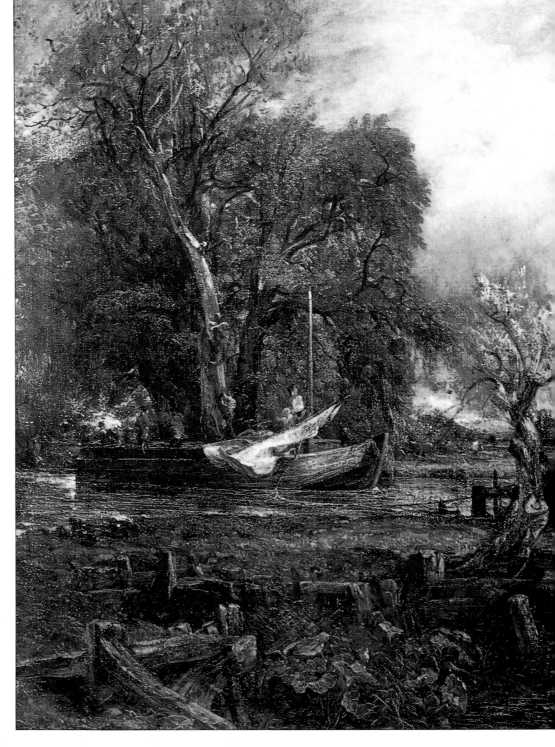

RIGHT *By the early 19th century artists such as Constable had absorbed many of the lessons so well taught by Claude Lorraine and the late 17th-century Dutch masters. As in so many of the 17th-century Dutch landscapes, Constable's figures are integrated into the rural scene, and canals and buildings play as important a role as the trees and sky. There is no sense of the savage wilderness in Constable's paintings and it is only in the skies that a sense of the power of natural forces can be felt. The subject matter of Constable's paintings were predominantly that of an agricultural landscape tamed by the hand of man. Constable usually first made rapid pencil drawings in note-books, followed by loose paintings in oil, then more detailed drawings and larger paintings.*

Look at all the objects in a landscape for their pictorial value and not for their sentimental or idealized value. A bright new metal grain storage tower can be as visually interesting to draw, with its reflections of light and colour, as any ancient windmill. One of the problems for the beginner in landscape is indecision over choosing a suitable subject. Beginners often travel miles to a known location of a pretty cottage . . . and make what is often a rather uninteresting drawing. If they were more aware of the pictorial possibilities they would see that their own back yard, with its heavily laden apple tree and the nextdoor cat sifting through the garbage, has all the makings of a pictorially interesting subject.

A convenient way to start drawing a landscape is to view the landscape through a viewing frame; this certainly helps to choose the best pictorial composition. For the beginner the frame is an essential piece of equipment. It is not absolutely vital to have a folding easel or a stool, but if a study is going to be made to a near-finished state out of doors it can be very tiring to stand in one place holding a sketchbook.

A word of advice on setting yourself up to draw: when you have decided where and what you are going to draw, try not to have the sun coming over your shoulder if possible, because the shadows cast by your hand or head can be inconvenient, as can glare off the paper. An added difficulty is that the bright light may tend to cause you to make your marks heavier than you really intend so that the tonal values of the drawing are disturbed. Ideally the drawing board and easel should just be into the shade; sit or stand as square on as you can to your subject matter; and if right-handed, have your easel and board slightly to your right so that you can see the subject matter and your board without moving.

Start by drawing a rectangle on your paper. This is to represent the picture-plane as seen through the viewing frame. Decide where you are going to start, and with a 4B pencil make a continuous line drawing of the scene in front of you that you have selected through your viewing frame, going around the main outline of all the large features.

Do not at this stage get involved in any detail because that could interfere with the overall structure and composition of the drawing. Once all the large features are drawn, add lines designating all the large areas that are in shadow. If you intend to use the drawing as a basis for a watercolour, you will probably have sufficient information for it at this stage.

If, however, you intend to take the drawing to the state of a finished work there and then, start working greater detail into areas in the middle ground, so that the drawing begins to develop a sense of three-dimensional space.

ABOVE AND ABOVE
RIGHT *You can see that by
altering the position of the
picture plane the
composition of this painting
is altered. In photography
every time you point your
camera in a slightly
different direction at the
same landscape you are
altering the camera's
picture plane and you will
therefore take a different
photograph. The artist's eye,
when working in a
representational manner, is
reacting to the landscape in
a similar way to the camera.
The simplest frame (far
right) will help you to decide
upon the most stimulating
picture plane for any scene.*

Obviously the initial drawing is very flat because all the objects are treated with the same intensity of line – quite light – irrespective of where they are spatially in the drawing. Those things furthest away in the drawing, such as trees or hedges on the horizon, need not be worked any more than they are at this point. In the middle ground, select those details that really are dominant and emphasize them. It is only those parts of the landscape really near to you that should be treated in any great detail.

Now start to outline the areas which are in deeper shadow within the already drawn area of shadow. Shade both these areas again. Now concentrate in greater detail on those areas of the composition that you have decided to make the focal point. If the focal point of your composition is in the middle distance, again, do not over-embellish. Successful drawings may depend far more on what is suggested to be there than what actually is. Always leave room in your composition for the imagination of the viewer. If the drawing is overdetailed, the viewer is not

encouraged to do more than scan, for all the information that is required for the viewer to understand what he or she is looking at is immediately apparent. If the middle ground is overdeveloped, it also makes it impossible to do anything with finer-detailed work on the immediate foreground.

To attempt to bring the whole composition to a high degree of finish, as many beginners do, may result in the drawing's just looking incredibly flat and cluttered with too much visual information, so that it may even become difficult to see the overall intention of your original concept. Remember that your mind perceives far more detail than is physically possible to record in your drawing. Select those elements of the composition that are visually most useful to you.

In the chapter on *Basic Practice* the theory of composition was briefly discussed. Like all theories it can be somewhat confusing unless some simplified practical application can be demonstrated that has more direct relevance to the problem in hand. Composition and the theory of the picture-plane are very closely

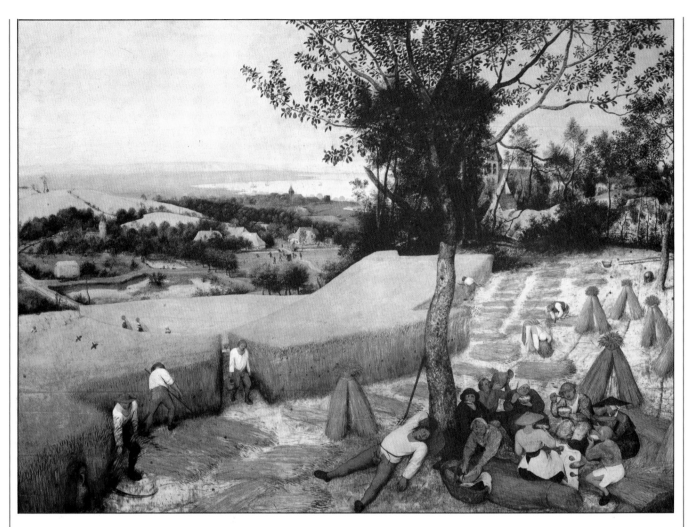

linked, and although they are often discussed as two separate issues they are inseparable in practice. By using a variable mount it is possible to alter the focal point and the whole picture-plane composition of the drawing. (This is discussed more fully in the chapter on *Still Life,* but the same basic practice applies equally to landscape or to any other subject matter).

Up to now all the exercises have involved the use only of the most basic of drawing instruments, the graphite pencil. To the beginner the pencil is the most obvious and commonly used drawing medium – indeed, the lay person often considers that a drawing can be done only with a pencil. There is nonetheless of course a great variety of media, the most commonly used of which are chalk, charcoal, conte crayon and ink.

Charcoal has many advantages for the beginner. Large areas of tone can be put in very rapidly, and the intensity can be varied by rubbing, blowing or brushing, etc; if you want to alter the form – ie shape – it can be easily done, moreover, with a soft putty eraser. The richness of tone achievable with charcoal is

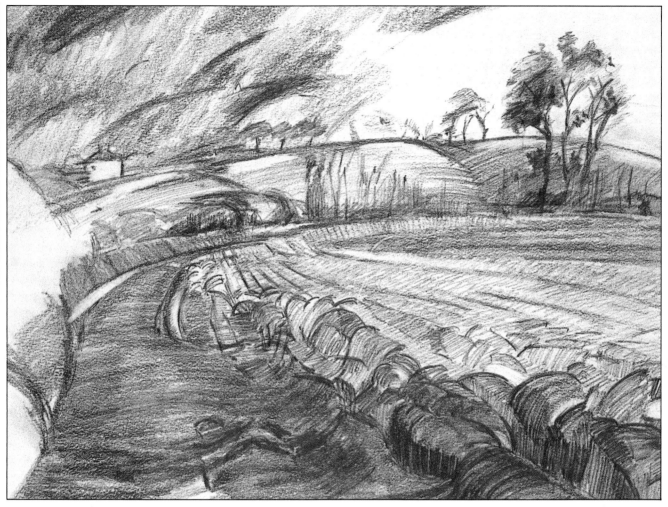

immense, from the palest of greys to the blackest of blacks, and with the addition of white chalk and a putty eraser to bring out highlights, charcoal as a medium can be fully utilized.

There are however two distinct disadvantages to charcoal when working out of doors. It is not unknown to have a drawing in an advanced state when a sudden gust of wind removes half your hard-won image before you have had time to apply a fixative. It is also quite a dirty medium. However, it is the vulnerability of the work while in progress that sometimes makes this not the most suitable medium for outdoor drawing for beginners.

Incidentally, for charcoal-drawing, a paper with a good tooth is necessary and a fixative to secure the charcoal to the paper is also absolutely essential.

Conte crayon and compressed charcoal behave in a not dissimilar manner, and the range of blacks to greys – particularly if used in conjunction with white conte – is equally as encompassing. Conte is held together by a slightly greasy gum substance. The facility to be able to spread it with your fingers or rub it out

OPPOSITE *In Breugel's painting* The Cornharvest *(1568) we have a very fine example of the use of strong geometrical form being used in a landscape painting. It is often thought, incorrectly, that landscape only comprises very soft and rounded shapes. This composition works particularly well as it contrasts the soft, rounded shapes of the trees with the hard edges of the cut cornfield. Such contrasts are even more apparent in modern landscape. It is often a good idea to make tracings from postcards of paintings you have seen to help clarify the compositional devices that might be missed if only a casual observation is carried out. Notice how the sheafs, the path between the corn, the corn laying on the ground, and the curve of the scythe held by the figure on the left, all help to turn the eye toward the main group of figures resting under the tree, which is the central subject matter.*

ABOVE *In this pencil drawing made on a late Autumn day, the strong lines of perspective of the freshly ploughed field lead the eye into the middle distance.*

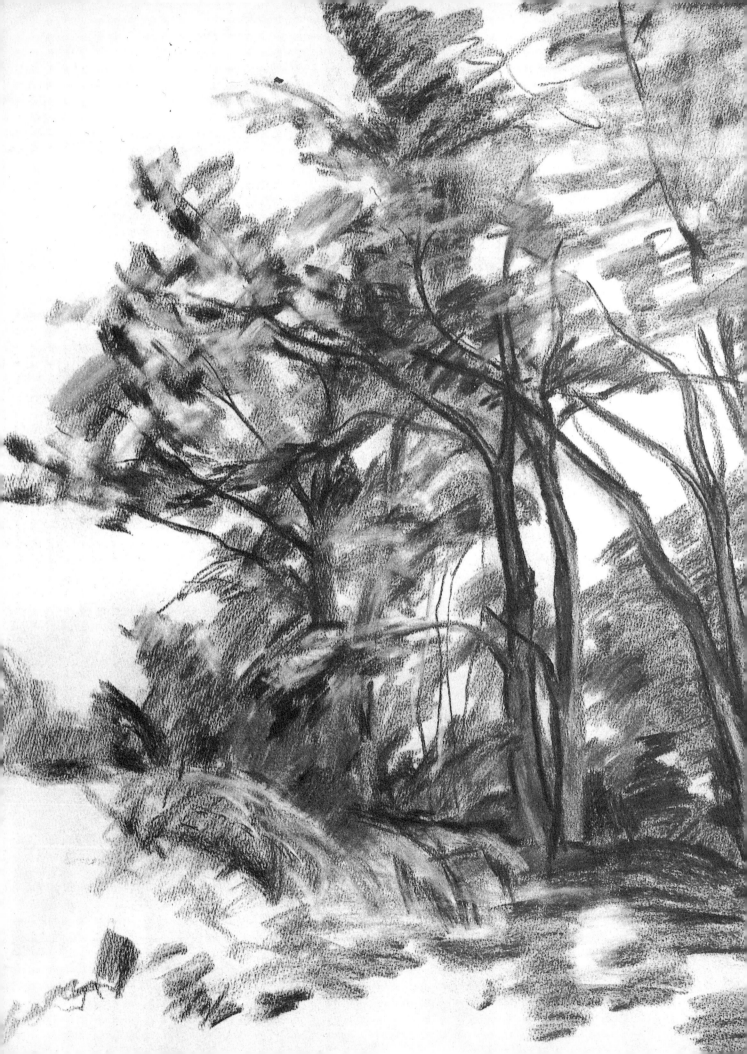

is much reduced, so it is necessary to have quite a positive approach to drawing. This is often best achieved by drawing in the large areas first using the conte very lightly to get the palest of greys possible and using this as a base from which to start building the intermediary greys right up to an intense black.

One of the most important elements in landscape is the sky, and cloud formations in particular. Many beginners find it extremely difficult, particularly with a pencil, to make a satisfactory rendering of clouds and sky. Perhaps one of the reasons for this is that the beginner quite naturally tends to choose only the best weather in which to go out drawing, when the full dramatic potential of the sky may not be at its best. Unless you are working in colour, the cloudless blue of a Mediterranean sky is almost impossible to draw or express. The only solution is to leave that part of your drawing completely untouched; the brightness of the light is then expressed by the vividity of the objects in the landscape and the intensity of the shadows being made by these objects, both of which give a visual clue to the glare of the otherwise blank sky.

However, in a more northern climate the sky can be the most dramatic element of landscape, and the works of the great English masters, Turner, Constable and Gainsborough show excellent examples of what can be done with the sky. Constable in particular made numerous studies of cloud formations, and his interest in the effect of weather visually on the landscape was almost scientific. He carried out many small paintings and drawings solely of cloud formations. It has often been suggested that his awareness of the vagaries of the Suffolk weather were developed in him at a very young age by his father, a miller who had

OPPOSITE *This stand of young saplings was rendered in charcoal and white chalk. The chalk has been used predominantly in the foliage and gives the impression of flickering light passing through the leaves. Other areas of light have been produced with a putty eraser and the whole drawing has a richness of tonal values that few other media can equal. The original drawing is quite light and measures 20 × 27in (50 × 68cm). It is drawn on a T.H. Saunders handmade rag paper. A paper of this type has a good tooth which allows the charcoal to be picked up in the grain. It would be impossible to get the very black tones with charcoal on a smooth paper. It is often advisable to fix the drawing lightly while it is in progress, particularly the very dark areas, as there is a tendency to knock the charcoal off the paper.*

ABOVE LEFT *This small sketch book study of an oak in full summer leaf rendered in graphite pencil shows the contrast between this medium and charcoal. The main difference is the intensity of the dark shapes. The pencil drawing only measures 8 × 6in (20 × 15cm). Although it would not be impossible, it would be extremely difficult to render a drawing the size of the one in charcoal with a graphite pencil. Similarly, charcoal would be unsuitable for making a drawing this size.*

ABOVE *In this conte drawing emphasis has been placed on the taut, twisting form of these old cherry trees, and the hard, crisp line is an ideal vehicle for expression when using conte, which smudges far less than charcoal. Conte can often be handled with more confidence by the beginner.*

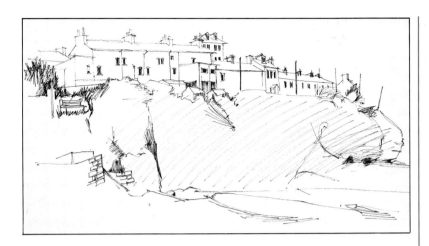

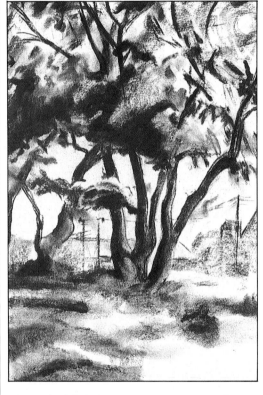

ABOVE *It might not be immediately apparent that this drawing was rendered in compressed charcoal, but compare this with the charcoal drawing of young saplings on page 44. Greater use has been made of the uniformly dense black quality that compressed charcoal can give. Although it can be spread more readily than conte, it produces a* harder crisper tone than natural charcoal. Both this and the saplings drawing are on the same type of paper and were drawn in a similar manner. In this drawing however, there is less subtlety of tone.

perforce to be aware of any sign of impending storm that might destroy his windmill if he was caught unawares.

Do not attempt anything too ambitious. Remember that you will be restricted by the limitation of a pencil, but make some cloud studies to find out what can be achieved in the medium. Many artists find charcoal and conte a more suitable medium for a composition where the cloud formations play a dominant role.

Ink may be a very satisfactory medium for landscape drawing, particularly when it is diluted with water and used with a brush. This approach allows for detailed tonal information to be recorded out of doors for use in the studio later. The technique of pen-and-wash drawing is very similar in approach to watercolour painting, in which the major part of the image is laid down with a brush, and only those parts of the drawing that must be sharply distinguished are rendered with a pen. A proficient facility with this medium can be the most rapid and direct way to record nature. Rembrandt drew almost exclusively in this medium. Its very fluidity makes it ideally suited to rapidly changing cloud formations and effects of light. Although a pen can be used in a similar way to a well sharpened pencil, such a linear approach can be rather laborious for the beginner. It is recommended that ink be used as a wash medium for landscape, with the pen playing a secondary role.

The theory of perspective has already been mentioned, and from the theoretical explanation it may appear this particular theory cannot be applied to landscape except when drawing buildings. However, this is not strictly correct. The theory of perspective is basically a pictorial device to work out the proportions of objects in space which are more or less the same size, but which have to be represented so that those that are nearer to you appear larger than those that are further away. For example, if you are looking out to sea, most of the waves in the distance are more or less the same size as those toward the shore, but

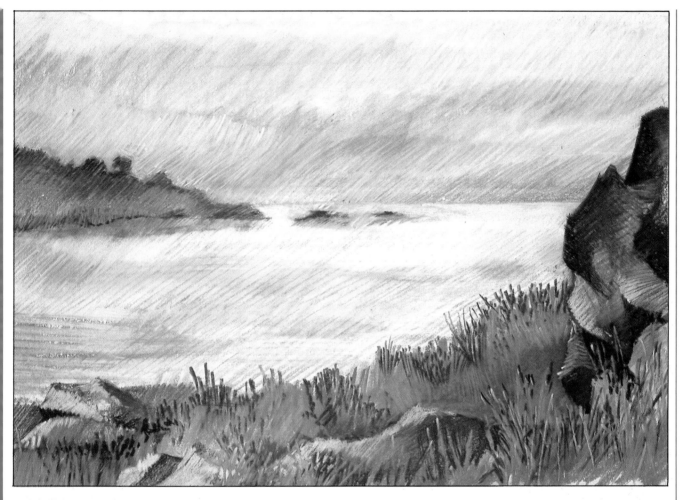

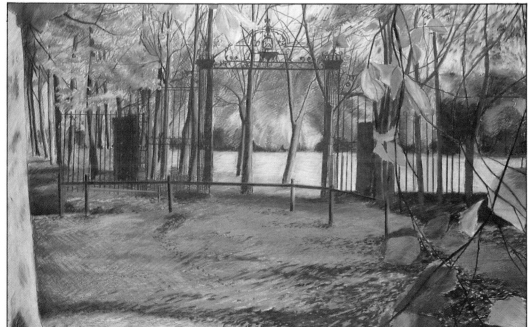

ABOVE *Seascape with rocks; this drawing is in pastel pencil, which is harder than the conventional pastel stick to master, but allows great control over the drawing. Pastel pencils do not blend together quite so easily, and subtlety of colour is achieved by overlaying one colour on another.*

LEFT *This urban landscape of trees seen through park gates is drawn in waxed-based coloured pencils. Again, great subtlety of colour is achieved by the overlaying of one colour on top of another, giving a richness similar to oil pastels.*

BELOW *In this drawing in oil pastels, distance and space have been created by two main pictorial devices: a graduation of the intensity of colour from the foreground to the horizon (the weakening of colour is due to the atmosphere between the viewer and the far distance) and clarity of line. Detail and structure of rocks nearer to the viewer are clearly defined. In the middle distance they are less defined, and so on, to the horizon. For a subject such as this, normal linear perspective would be difficult to apply. Atmospheric perspective is* easier to create when the subject matter is in full colour.

RIGHT *A pencil landscape in which the reflected light from the clouds has been used to illuminate this drawing. Notice in reality how the sun reflects off the clouds sending beams of light often running contrary to the main light source.*

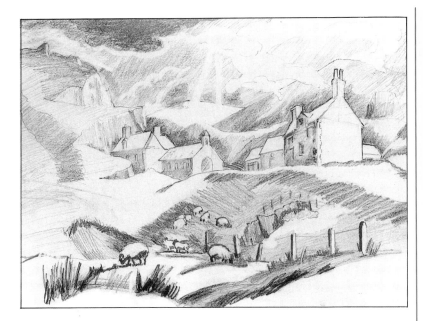

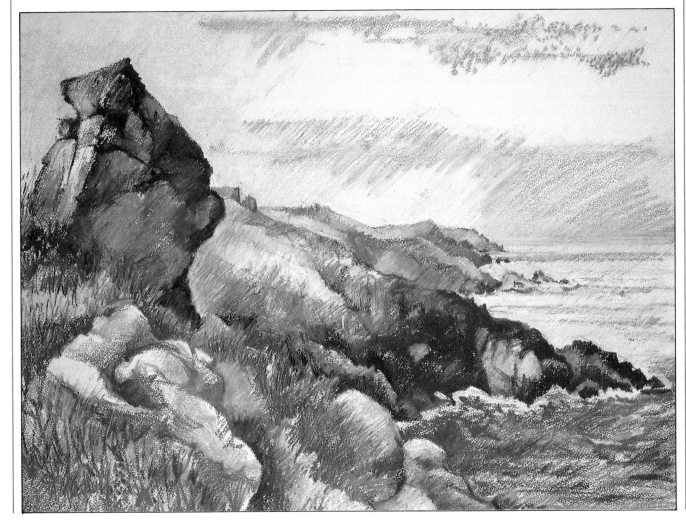

those nearer to you appear larger than those further away. By using perspective you can determine the relative size of the waves as they recede towards the horizon. If the theory of linear perspective is applied to the sea, a greater sense of space is achieved than merely drawing the waves in an arbitrary manner.

Certain cloud formations can also be drawn using linear perspective. Clouds recede towards the horizon; perspective can help to achieve the appearance of a sky that is more than just a backdrop behind the landscape being drawn. It is sometimes not clearly understood that the clouds are above the landscape being drawn. The use of linear perspective can help achieve an understanding of the three-dimensional quality of the sky.

There are many other parts of a landscape to which perspective can be applied. Hedges and roads are two particular examples that are very useful in forcing the eye from the foreground to the middle ground through the use of perspective. Although hedges do not have the linear structure of a row of buildings, they are normally of uniform height throughout their length. Even an untrimmed hedge is made up of a number of individual bushes: left untrimmed, they return to their natural shape, but each individual bush is more or less the same size. By drawing the hedge as a series of individual bushes which appear to get smaller as they recede into the distance, it is possible to draw them following a line of perspective in the same way as if the bushes were a brick wall.

A useful pictorial device can also be made of a row of telegraph and power cable poles, particularly in that they are very rarely dead upright and tend to lean in slightly opposite directions, giving the composition a certain rhythm. Cows are a favourite pictorial device for the landscape artist. Our previous knowledge tells us that cows are all more or less the same size. Two or three cows in a field at various distances again give the painting a perspective depth. Indeed, any objects that the viewer expects to be about the same size are of great pictorial value in giving a drawing a sense of scale. However, some care should be taken because a beginner can quite easily draw a distant cow or sheep too large and with too much detail – which completely destroys the sense of scale in the whole composition.

From these examples and the illustrations, you should immediately start becoming more aware of objects in a landscape which are pictorially most useful. The term 'perspective' should not be applied only to the theory of linear perspective, as in architecture. 'Getting something in perspective' is often used as a literal term, meaning giving things their due comparative importance. Careful comparative observation of objects as demonstrated through the glass screen picture-plane exercise should achieve the same result pictorially. Do not make mechanical perspective a substitute for accurate observation.

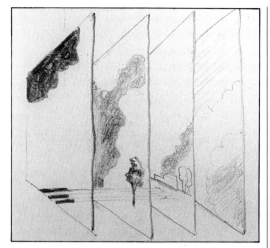

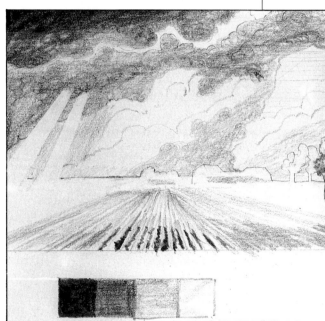

To illustrate the ploughing on the field here, normal linear perspective can be used, but how do you create atmospheric perspective when a drawing is in monochrome? Imagine that the picture is made up of four sheets (top), and that which is nearest to you is the darkest and on the first sheet, that which is in the middle distance is on the next sheet, and that in the furthest distance going towards the horizon is on the next. The fourth sheet represents the endlessness of the sky. The sky is often represented as a backdrop to the landscape, but this is a mistake. The clouds also are represented on each of the 'sheets'; the ones closest to you are darkest, fading toward the horizon and the fourth sheet. In this way atmospheric perspective is applied both to the land and the sky. (The tonal range of a 3B pencil is indicated in the scale at the bottom of the drawing.)

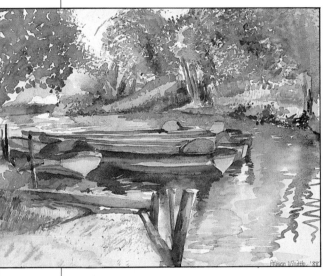

Aerial perspective is a further development of linear perspective. Instead of following a structural framework it is based on the idea that what is nearest to you can be seen in sharper detail than the same object would be seen in the middle or distant ground.

This theory in particular applies to colour. If you paint three identical pieces of board bright red and place one ten feet away from you, one 200 feet away, and the last 400 feet away, and get them all in line, the nearest board would apparently be the brightest and most intense red, and the colour would diminish in intensity the further away it was.

The result of this ratio between intensity and distance is called 'value' and to translate value into drawing where colour is not being used it is necessary to find an equivalent in greys to represent these differences. An exact representation of colour is of course impossible.

Another method of applying this theory is to draw an object that is nearer to you in a darker line and with more detail, lightening the intensity of the line and reducing the amount of detail until you arrive at the furthest distance, which is then just lightly outlined. The reverse is true in terms of highlight. The brightest highlight is used for an object near to you, again diminishing, becoming more grey as it goes back in space. Consider the highlights on top of the nearest waves in the storm scene opposite, where the paper has been left almost untouched. The waves in the middle and far distance have little or no highlights, and their intensity is also progressively diminished.

Painters who go out to draw and to collect specific information about the landscape often have a whole range of personal reminders. With practice beginners will likewise start to develop their own particular ways of dealing with tone and colour. The most commonly used device is to actually write on the drawing a description of the colour, time of day and weather conditions, with cross-hatching to show areas in shadow (cross-hatching more closely those areas near to you and broadening the hatching out to show the same effect further away), and with arrows showing the direction of the light.

Another device is to take for example a point on a hedge, follow down a natural line of perspective and at intervals develop part of the hedge in more detail. The eye naturally follows down those areas of more visual activity, thereby combining linear perspective and aerial perspective in one statement.

The beginner often finds this theory of aerial perspective the most difficult to comprehend. It is better not to make any hard-and-fast theoretical rules but to have some idea of the basic concept at this stage and let it develop with experience; to have a working knowledge and let the actual experience of drawing teach you by practical application.

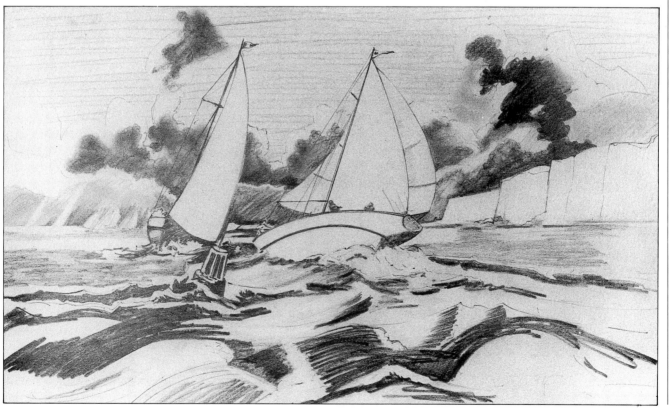

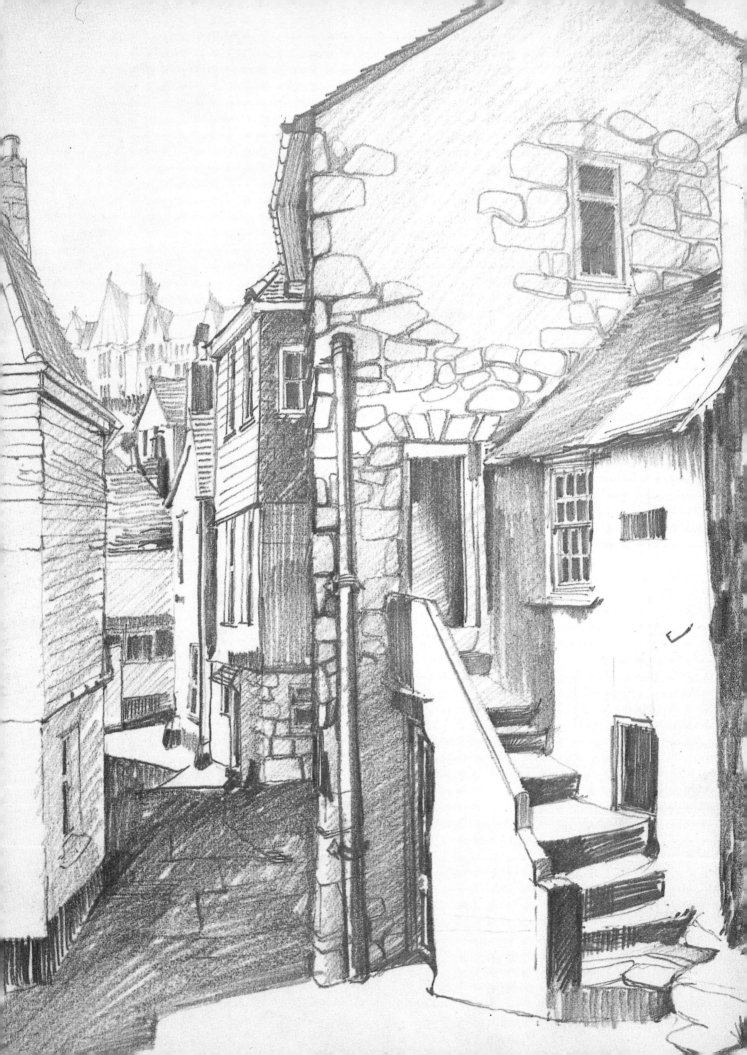

BUILDINGS AND TOWNSCAPE

LEFT *This pencil study is a good example of multi-point perspective. All the elements make for complication; the rising steps on one side and the lane moving away downhill on the other, and the fact that none of the buildings are square to one another, make it very difficult for the beginner to work out all the various vanishing points. The viewing frame should be used to understand the relationship of all the elements. With practice, the student will gain enough confidence to use his or her eyes without the necessity to refer to the laws of multi-point perspective.*

*A*LL THE THEORIES and pictorial attitudes that have already been discussed in the chapter on *Landscape* apply equally well to the study of Townscape and Buildings. It is possible to make a very successful drawing of landscape where no buildings at all are present, but the inclusion of buildings adds a further pictorial element which can be used to great effect. The geometrical precision of buildings when used in contrast to natural landscape can create a visual tension, and the same is equally true in reverse of a row of trees lining a central city street, which add an organic contrast to the geometrical hardness of the adjacent buildings.

There are many artists who have found a lifetime of subject matter in an urban environment. Beginners may be reluctant to tackle such subject matter because they feel that a picture so composed must include people and a deep understanding of perspective. Several notable artists have painted street scenes completely devoid of any figures; indeed, Utrillo, the French 20th-century painter of Montmartre street scenes, in the majority of his paintings, allowed figures to play only a very minor role or none at all.

Canaletto's fascination with his native city of Venice, where the effects of the crisp northern Italian light brought a supreme degree of clarity to that architectural subject matter, greatly influenced many artists of succeeding generations (see illustration, page 54). Even today, many photographic souvenir postcards are taken of that city and others in a way that echo his archetypal view. It took succeeding generations of artists to realize and come to terms with the idea that cities cannot always be seen in a clean, clear light that makes every detail of the architecture visible. The modern industrial city can rarely be seen to such clear effect, for smog and grime more often than not wrap the buildings in a cloak of tonal mystery.

For the beginner who wishes to seriously tackle the subject of townscape it is essential to approach the city with an open eye and an open mind. It is impossible, even in Venice, to find every wall free of graffiti or street free of litter (and for much of the year even Venice is cloaked in a heavy mist).

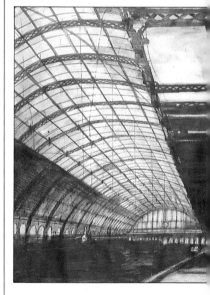

ABOVE *A pencil and wash study of the glass roof of a Victorian railway station, London. This drawing relies upon a painstaking control of perspective as well as silhouette to create a cavernous expanse of glass and steel.*

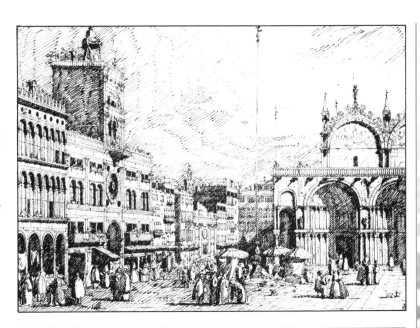

OPPOSITE *Pencil and wash study in the tradition of typographical art. It accurately records an aspect of Trafalgar Square, London, without really making any comment about the life of the city. The same style of drawing could be used to depict any city.*

RIGHT North East corner of Piazza San Marco, *Antonio Canaletto: Canaletto is one of the great masters of linear perspective and many of his works have a photographic accuracy. He often worked to achieve*

this accuracy with a 'camera obscura'. This was a drawing aid very popular with typographical artists that accompanied many gentlemen on the Grand Tour of Europe. It works in a similar way to a single lens reflex camera, but instead of the image being projected onto a sheet of film it is projected onto a sheet of paper or glass and the image is then transposed with a pencil. Although a knowledge of perspective is useful, it is by no means essential when drawing the contemporary urban environment.

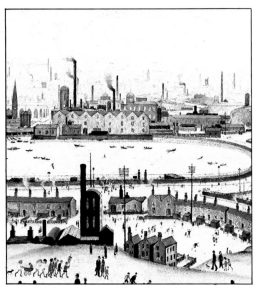

The Pond by *L.S. Lowry: Lowry's approach to townscape differs from Canaletto, in that the city acts as the environment for the ant-like inhabitants that Lowry makes the main theme of his paintings, he makes little attempt to glorify the buildings of the city. The Canaletto concentrates on the beauty of architecture, and the inhabitants play a secondary role. The aerial view in this painting enables the viewer to embrace a wide*

panorama. It is a very personal approach to perspective which does not offer any one dominant centre of activity.

It is interesting to note how the tones lighten from the foreground to the background when the same painting is produced monochromatically, faithfully reflecting the technique for monochrome rendering of atmospheric perspective.

It is not necessary to live in a great metropolis or city renowned for its architectural beauty. Any town or small industrial centre can provide a lifetime of subject matter for the sensitive observer, and even the uniformity of many suburban streets can present a pictorial rhythm unique to the local environment. A row of identical suburban villas might not seem a likely subject, but if the artist concentrates on those details that the owners have added to their homes to give individuality to what were originally identical structures, an interesting drawing can be made of what might otherwise have been dismissed as a mundane and commonplace subject.

In the late 19th and early 20th century, the smoky industrial city of Manchester in the north of England would have seemed

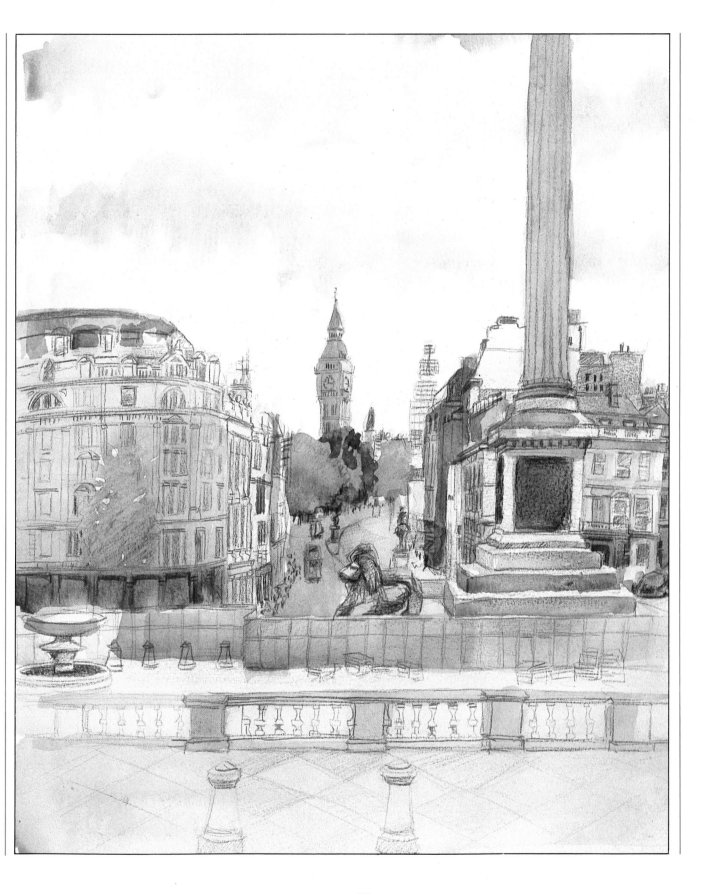

TOP *Pencil study of a public house depicting the building in a clear and concise manner. No attempt has been made to include* *people on what would normally be a busy thoroughfare. The subject of this drawing is categorically the building.*

the most unlikely subject matter for great art, but L. S. Lowry, with his acute observation, was able to compose paintings of great human warmth from what many of his contemporaries would have considered an uninspiring environment.

Our own contemporary environment presents just as many possibilities. Brightly coloured motorcars stacked in rows in a drab concrete multistorey car park could quite easily be turned into an interesting pictorial study. The grotesque silhouette of an industrial plant, which obeys none of the proportions necessary in an inhabited building, can give the artist a whole range of visual possibilities: such structures obey their own strong logic governed by the industrial processes they are designed to serve. There are now strong shapes jutting into the skyline, venting wispy clouds very different in form from the natural cloud formations that they are about to join.

Another area of townscape that is well worth investigation is the forest of billboards and fluorescent displays that give any shopping precinct its great visual variety of shapes and colours. The city at night can be particularly visually exciting, its multitude of light sources casting shadows in all directions. A good beginning for a work done at night might be a gas station, with its constant movement and brightly lit forecourt, the reds and blues of the pumps and billboards representing an oasis of light and colour in an otherwise dimly lit suburban street.

For those students who wish to represent the townscape in a less impressionistic manner, a working knowledge of perspective is very useful. But because few streets are built dead straight or uniformly, simple, two-point perspective is essentially too limiting and an understanding of the laws of multi-vanishing-point perspective is more useful. However, it is not necessary to

FAR LEFT *The French artist, Utrillo, who was painting pictures of Paris at the same time that Lowry was painting pictures of Manchester, England, had a very different approach to the contemporary urban environment. Utrillo's paintings convey an eerie emptiness and sense of isolation. The city is not used as a backdrop for figures but is used to create a melancholy mood.*

ABOVE *A pen line drawing in which the building is isolated from its surroundings. This type of drawing usually illustrates a builder's or architect's brochure. There might of course be a power station behind the building, but the aim of this drawing is to concentrate the viewer's mind on the building that is for sale.*

study perspective independently of undergoing the experience of actually drawing. If the pictorial basics of good observation and the picture-plane are clearly understood, an exciting rendition of a townscape can be successfully completed with the minimum of perspective knowledge.

Take any street scene and view it as you would a landscape, through a viewing-frame. Draw a picture-plane on your paper. Now draw a continuous line corresponding first of all to the overall silhouette of the major buildings nearest to you. (There is no more difficulty in drawing buildings than in drawing cardboard cartons.) Try to avoid seeing each building individually. See the whole street as a continuous shape that is divided into individual buildings by the addition of the features that make each building separate from its neighbour. Observe how a large building at the end of the street appears smaller than a more modest building nearer to you, and how a relatively close traffic sign can obscure your view of even the largest buildings. Again the main problem is in believing what you see and having the confidence to record it.

The visual possibilities of townscape are very broad, from a large panoramic view of the city drawn from a high vantage-point, to a closely observed view through the half-open gates of a factory yard.

The first attempt for those who do not have easy access to a town could well be to portray a local church. This is a much-worked subject for beginners . . . and many of the resultant drawings are quite uninteresting because the drawing is carried out in purely topographical terms. But there are other ways in which to tackle such drawings, and indeed with imagination this type of subject has many possibilities. Street scenes of villages and small towns have considerable visual potential. Corner shops, squares and market places, statues and war memorials, all hold great pictorial value. Again it is often the contrasts of architectural periods in buildings and their proximity to contemporary constructions that can give an interesting visual twist to a contemporary scene.

For those with a little more confidence, the inclusion of people in a town or village scene can add another dimension. There is no need to be a master of anatomical drawing to include figures in this type of work. Look again at the range of human personality that Lowry was able to express with the minimum of anatomical detail. Once again it is sharp observation of human character which is all-important to give a beginner the confidence to include figures in his or her drawing.

As in drawing a landscape, try not to ignore those things that you might feel to be an intrusion of modern life on the town, such as traffic signals and signs, refuse containers, etc. You might not like them, but they are indispensable pictorially. Many be-

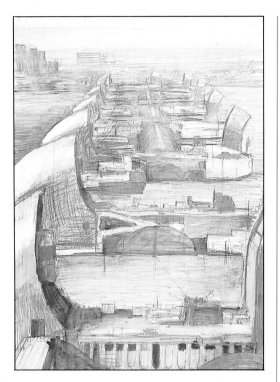

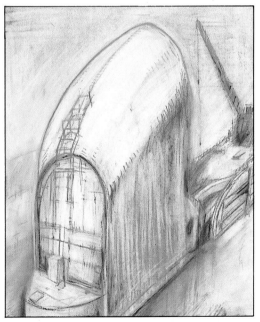

Harlem *by Edward Burra (1934); the vibrancy of the city is captured in the juxtaposition of hard and soft textures and the peculiar perspective, which implies that the upper windows are stuck to the wall rather than being a part of it.*

Pen and wash studies of the Thames Barrier, London; in these two drawings an optimistic, vibrant view of man's achievement in the urban environment is presented. A putty eraser has been used extensively to lift the light areas.

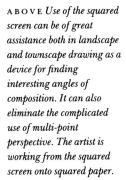

ABOVE RIGHT *Churches can be a good architectural subject for the beginner, because they are sometimes situated where a lengthy study can be undertaken without too much disturbance. The drawing in sepia conte crayon is typical of a beginner's approach. An attempt has been made to depict the building in a clear and concise manner. The result is not outstanding, either in composition or drawing technique, although it is quite competent. It has little interest in itself to anyone who is not familiar with this particular church.*

ginners omit these things from their drawings in an attempt to portray a street scene of predominantly older buildings, as though the drawing was done when the buildings were first erected in perhaps the 19th century. Works carried out in this frame of mind inevitably look unconvincing because many other pictorial elements that would have been present in the 19th century are not there – particularly horses and carts, and figures in period costume. Try to see the view in front of you in terms of its pictorial value in a specifically contemporary sense.

Artists in the 20th century have tended to look at the city in an expressionist and abstract manner. A cool, analytical, perspective study of a city street can often miss the essential quality of vibrance, noise and excitement that the city expresses to those who live in it. Expressionist drawings may not be accurate representations of the city, but they may poignantly and emotively convey a sense of urban vibrance. John Martin's watercolour drawing of the Singer building, painted in 1921, has a greater sense of turmoil of the metropolitan street scene than an ordinary perspective drawing or a photograph could ever convey. A work like this is conceived pictorially on more than one level. Similarly, Edward Burra's watercolour *Harlem* (1934) displays a peculiar perspective which suggests that the windows are disattached from the buildings (see page 58). It is not too fanciful to say that such a work has the disjointed atmosphere and vibrant harmony of a jazz composition. Compare the work of Canaletto, Lowry, Utrillo and Burra to discover the four main approaches to townscape. Many of the expressionist works of the 20th century take this multi-point view in one work.

It would often be impractical or very difficult to approach drawing a townscape in the same manner as drawing a landscape; there is not least the difficulty of trying to set up an easel and stool in a busy shopping street, and it is the tackling of such a subject surrounded by physical complications that brings a full realization to the beginner of the usefulness of a sketchbook.

Artists have different ideas about working from sketchbook notes but a useful approach is to think of your sketchbook as a visual diary in which on a day-to-day basis you record those things that are visually stimulating, gathering as much visual information in your quick drawings as possible. Beginners often get the wrong impression about what a sketchbook is for, and fill it with ill-conceived and rather scribbled drawings which two days after they have been done are visually unreadable and carry insufficient information to be of any real value in the

ABOVE *With the use of a squared screen the artist found a more interesting and unusual aspect of the same church. This pencil study was started on a late Autumn evening and finished later in the studio. The artist exploited the fact that the sun was low on the horizon on the left-hand side, bathing the tower in a pink glow of light and plunging the body of the church into deep shadow. The last of the sun catches the tombstones in the foregrouind and sets them brilliantly against the dark shadows. With the early moon in the right hand corner, this pastel study is given an eerie melancholy; a marked contrast to the pedestrian study of the other side of the church.*

RIGHT *This pencil drawing was executed in a manner described in the chapter on Basic Concepts. The buildings are not viewed individually at first; the artist starts by making a continuous line drawing from left to right going around the trees, up and down the chimneys, across roofs, up the church, creating a silhouette against the skyline. When this simple, continuous line is completed, all the large shapes are drawn relative to one another immediately. Then the detail of the church spire and windows of the houses are added. There is a concentration of detail around the church, but at the edges of the picture plane far less is incorporated. The work appears to be full of interesting and painstaking detail, but with practice this type of drawing can be done quite rapidly and accurately. This particular example was executed in a sketch book 11½ × 16½in (28 × 40cm). The original has been considerably reduced for reproduction, which makes it appear much more condensed than it actually is. When they first look at an art book beginners often make the mistake of trying to reproduce drawings the size they appear in the book.*

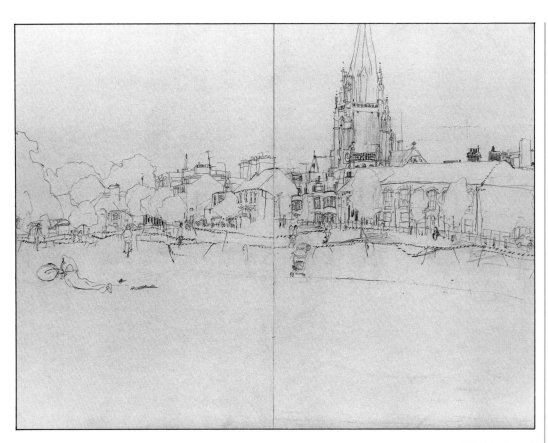

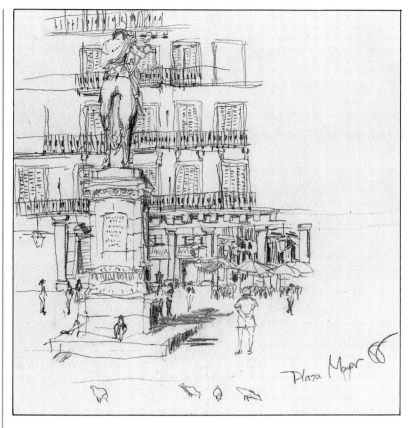

LEFT *Notice how in this pencil drawing the shutters are not drawn in any great detail, but the right density of mark has been used to indicate the louvres. The cast iron railings in the front are drawn in an almost identical but heavier mark, giving them weight and bringing them into the foreground.*

BELOW *City parks can be an excellent source of inspiration. The juxtaposition of architecture and nature provides visual variety. Notice that the woman waiting at the bus stop, the TV aerials and traffic have all been included. It is a redundant exercise to leave out details of the urban landscape to create a 'pretty' picture.*

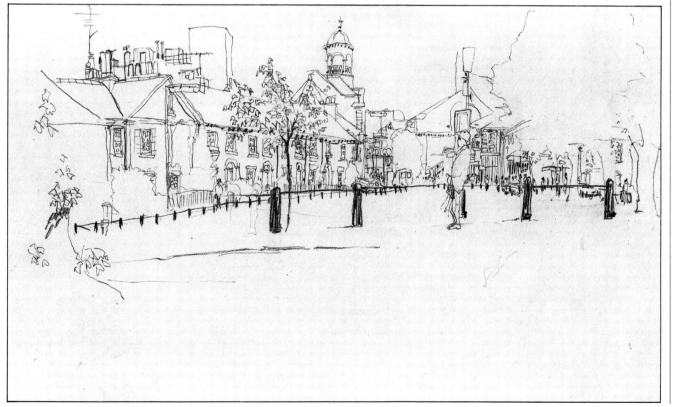

1

2

All parallel lines which recede into the distance appear to get closer together until they eventually converge at a point, called the vanishing point (above). The angles at which these lines converge depends upon the spectator's position LEFT.

LEFT *In one-point perspective only two faces of the cube are visible. One side is seen straight on, and there is only one vanishing point.*

3

4

LEFT *Vanishing points are located on the horizon line. However, they will often be obscured by buildings or other objects. When this occurs, it is nevertheless crucial to know where the vanishing points would be located. Although the converging lines will not reach their ultimate destinations, only by locating their vanishing points will you be able to judge the correct angles.*

studio. The sketchbook should be considered the training-ground for quick, accurate drawings in which every line and every mark conveys the maximum of visual information. It is better to record one small detail well than to plaster a page full of arbitrary marks which may mean something to you in the heat of the moment, but which in hindsight convey too loose an impression. The real function of a sketchbook is to record accurate visual information that can be useful in the studio, that can be included in a larger composition, and that can impart to the final work authority and meaning.

Most artists dealing with a townscape subject make their finished works in the studio using a whole range of visual notes collected over a period of time. For example, the overall composition may be decided from a quite simple continuous line drawing, but it may then be found to have insufficient information about doors and windows. Drawings of windows, doors, and other details, should be drawn separately in a sketchbook on a larger scale, as should details of street furniture. Your work might require a group of people on a corner waiting to cross the road. These could well have been drawn on another corner in another town, but if they fit the composition they can be used. You might, for example, want a row of parked cars. Again, these could be drawn as a totally separate study. All these images are brought together from the sketchbook to your finished work. Your original drawing for the composition would in any case be too small in size to carry the amount of detail that you require to complete a finished work.

As an exercise, try making a drawing from a series of sketches and notes done in one location. When you start to draw your townscape in the studio from your sketches, you will soon discover the sort of information that you should have recorded. Go again to the same location and make some more sketches. In this practical way you will soon understand what you need to record for the sketches to be of any real value. It is particularly when drawing a townscape that the sketchbook is most useful.

Obviously, not all finished townscape drawings have to be a composite of work from a sketchbook; many works can be finished on location. This depends to a large extent on where you can position yourself, although as a general attitude try not to let the convenience of a particular site dictate the viewpoint from which you draw. There will inevitably be interruptions by people looking over your shoulder when you draw in a busy place, and although this can be quite embarrassing, and disturbing, for a beginner you will, after a few attempts, become quite brazen and indifferent to the comments of passers-by. A more positive approach is thus required for townscape drawing than is required for the more lonely activity of drawing in the countryside.

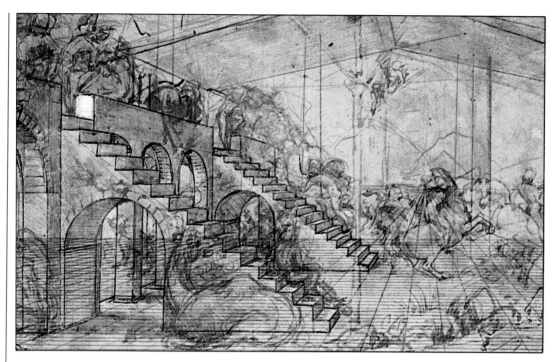

LEFT *Leonardo da Vinci's pen and ink preparatory study for the background to the* Adoration of the Magi. *Note the vanishing point to the right of centre.*

BELOW *A vacation sketch book study in pencil; the strong perspective gives a sense of towering scale. Again, a squared viewing frame helps to find and isolate the pictorial value of subject matter like this, so easily overlooked.*

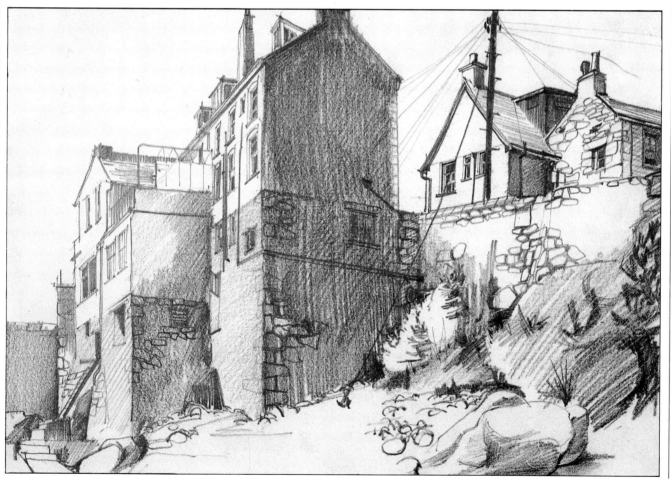

CHAPTER FIVE

STILL LIFE

LEFT *This pastel drawing of a hall table with a vase of flowers uses the hall mirror as a device to thrust the drawing back into the space being occupied by the viewer. A touch of mystery is added by the figure at the door. Are they leaving or entering? This pictorial device was much used by artists in the 17th and 18th centuries.*

STILL LIFE as subject matter has a long history. There is literary evidence of wall paintings of fruit and flowers in the ancient Greek period, and although no actual examples survive to this day, there are numerous examples from the Roman period which are probably copies of earlier Greek motifs. It is natural that many of the works that survive are mosaics, for these are less liable to decay and damage. Although mosaics are made by setting coloured marble and stone into mortar, the realism and sophistication of these works are often more exciting than the surviving Roman *trompe l'oeil* fresco paintings, in which the colour has lost much of its brilliance.

Throughout the Middle Ages there was a strong accent in all the arts toward religious subjects, and it is only in a secondary role that nature and still life were depicted, in the form of carved low relief patterns on architectural columns and door and window arches, and these cannot really be counted as still life representations.

It was not until the Renaissance that realistic representations of the natural world were again considered acceptable subject matter for the artist, and in northern Europe – where a striving for realistic representation took a stronger hold in the 16th and 17th centuries – still life again came to be treated by the artist as a genuine subject in itself.

The words 'still life' come from the Dutch words, *stil leven*, which describe any painting or drawing of inanimate objects.

In the famous painting by Holbein (page 69) all the objects between the two figures represent by themselves a wonderfully descriptive still life, but they are of secondary importance to the main subject, the two figures. Here the objects of the still life give an indication of the two noblemen's interests in music, astronomy and navigation. Even as late as 1533, when Holbein painted *The Ambassadors*, the majority of still lifes were incorporated as secondary visual subject matter, often for narrative reasons. In the Holbein painting, the collection of astronomical and musical instruments are included to reveal the history of the two men depicted. A generation or so later, in Caravaggio's *The Supper At Emmaus*, the beautifully rendered still life in the fore-

ABOVE *Still life with Gun, by Pieter van Steenwyck; this 17th-century Dutch painting displays the artist's mastery of glass and metallic surfaces. Many painters executed very detailed still lifes to advertise their technical proficiency in the hope of commissions.*

ABOVE The Supper at Emmeus by Caravaggio; the still life group clearly forms a central part of the composition, an arrangement to be found in many of the artist's works. The fruit is autumnal (the wrong time of the year from the biblical account) a pointer to the very secular approach to the religious subject. The foliage seen through the window is suggestive of a Japanese print.

ground is also used as a narrative visual device. However, a few years previously, Caravaggio had painted an almost identical, independent still life arranged in the same manner. There is, though, no record of Holbein's making an independent painting of the musical instruments as a still life painting.

By the end of the 17th century, Willem Kalf's paintings had many of the commonly recognized features of still life painting as an independent art form. Many of his still lifes were of tables laden with various kinds of food, often with symbolic overtones. The 'spread table' theme was a recurring one in both Flemish and Dutch still life. In his elegant compositions, reflections and transparent surfaces are often contrasted with dense textures and glowing colours. The Dutch still life school combined several related but separate traditions, each one with its own centre of production. Flower paintings were popular all over the country: each tiny drop of water, each leaf vein and petal was described with astounding skill and accuracy.

Symbolism of the kind employed by Kalf, in which the objects depicted represented the interests of the commissioners of the

The Ambassadors, *Hans Holbein, commissioned in 1533; the still life central section is symbolic of the interests of the two men and emphasizes their Renaissance learning and culture. It also divides the two figures, indicating a formal, rather than an intimate, ralationship. Note the distorted skull at their feet, a grim and curious counterpoint to the secular, worldly self-confidence above.*

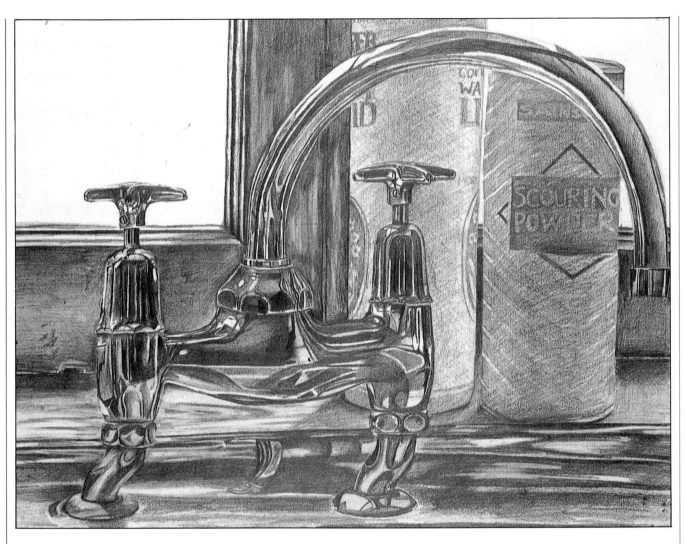

ABOVE *This pencil study shows the influence of Baroque still life painting in a modern study. The complexity of the reflections are rendered in a manner that shows the student's skill and competence in tackling a highly polished and complex reflected surface.*

work, was common throughout the 17th and 18th centuries, particularly in Holland, where the art of still life rose to a fullness of expression and painting skill that re-mains unsurpassed. This style of still life was used as a model of how the subject matter should be handled into the late 19th and early 20th century. It took such artists as Van Gogh, Braque and Picasso to breathe new inspiration into and create a contemporary approach to still life. However, Braque's and Picasso's works in still life are of a Cubist and abstract nature; their works are not representational and are therefore outside the remit of this book.

The painting *The Chimneypiece* by Édouard Vuillard brings still life painting in its representational form into modern times. Vuillard painted many works similar to the one illustrated right up until his death in 1940. In this painting there are no people present, but the haphazard nature of the objects about the room give the viewer an intimate insight into the occupants' lives. The summer flowers set the time of year; the medicines imply either

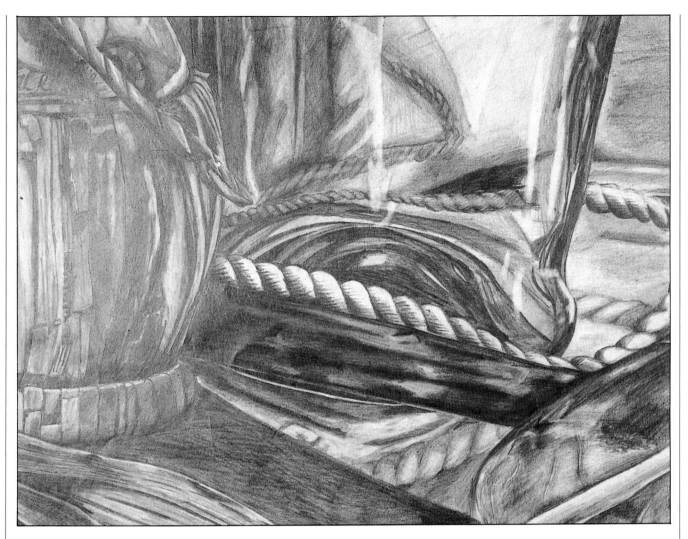

illness or hypochondria. The sombre tones of the work and the washing drying by the fire suggest a dull, rainy, rather claustrophobic summer day. The apparently casual placing of all the objects in the painting also suggests an easy intimacy.

From the examples shown, still life need not be the dull subject that it is often thought to be. A well rendered drawing of part of your own table after an evening meal, or a child's room after he or she has left for school, could give an intimate and telling picture of personalities and of lifestyle. The best contemporary still lifes are often those depicting natural corners of the everyday world. The dullness commonly associated with still life is to a large extent often due to the objects chosen and the forced and unconvincing way they are arranged as a subject for drawing and painting.

With your drawing board, and without any preconceived ideas as to what would make a good subject, just walk around your home and find an interesting corner, bathroom shelf or

ABOVE *A finely rendered pencil study which captures the delicate textural differences with almost photographic precision; the reflection in the glass has been achieved with the use of an eraser to bring out the highlights.*

This early 20th century still life painting by Edouard Vuillard The Chimneypiece *painted in 1905 is very different from 17th century Dutch Baroque painting. The very informality of the arrangement of the subject matter makes this painting appear a casual observation of a corner of a well-used room, and none of the objects is endowed with any individual or grand significance. The meaning of this painting relies almost entirely on the inter-relationship of extremely commonplace objects.*

This charcoal drawing of a well worn pair of shoes on a stool has been rendered in a way to give a sense of the character, not only of the shoes, but also of the wearer.

bedside table. Do not rearrange anything. The objects' unintentional and natural positioning may well be visually more interesting than any arrangement you could make even using your best china, favourite clock or any other treasured object. Start by making a simple line drawing. Try to resist the temptation to see the objects individually at first. Draw the main shapes and their interrelationships. Many well painted flower studies are spoiled because the vase in which the flowers stand is so often drawn in an unconvincing manner. Always remember that when you draw, the shapes being made on the paper are all interdependent on one another. The negative shapes are just as important as the positive shapes.

In your search for subject matter a viewing-frame can be very useful. Do as many drawings as you can to practise looking for subject matter. Do not be too selective: do not think that what is familiar to you is not worth the effort to draw. One of the great problems that the beginner has in still life and in landscape is indecision over choosing what to draw. Such indecision is often caused by the fact that to make a drawing demands a considerable effort from beginners and they therefore feel that their view must be directed towards a subject that warrants such effort on their part. This results in their simply dismissing many highly pictorial subjects because the assumed status of the view in front of them does not appear to warrant the effort involved. The commonplace object can nevertheless become a special, highly interesting and emotively charged object when drawn by an artist.

This is to return once again to the problem of seeing the pictorial possibilities of what is around you all the time. Things change by the light in which they are seen. What could be a very

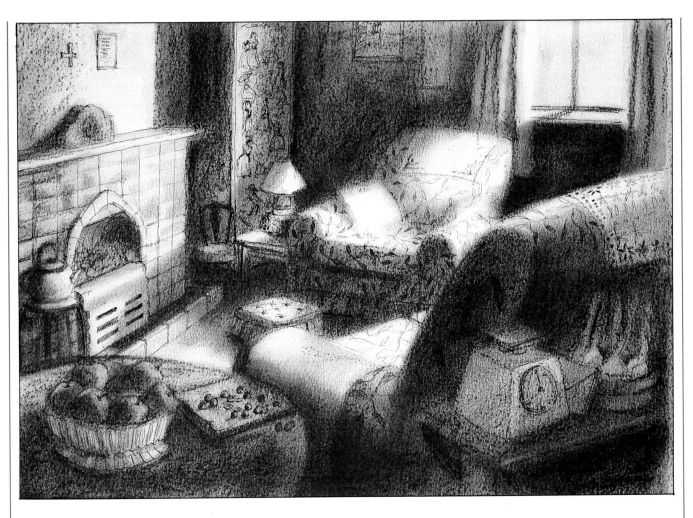

uninteresting landscape on a bright, sunlit day might on a cloudy and stormy day be most interesting and exciting. This may seem obvious in the context of a landscape, but the same is true of objects in a still life. The play of light is one of the most important elements, and the shapes and colours of objects change constantly under the effect of changing light.

As an exercise, collect together four or five household objects that are no longer required for everyday use. Give them a coating of white emulsion paint so that they all appear to be made of plaster. The whiteness of the objects will help you to see the effect light has in causing shadows. Set up your still life in a convenient corner, and with the aid of an adjustable lamp, direct light from one specific direction onto these now white but familiar shapes. Keep your drawing board as upright as conveniently possible and, remembering the picture-plane concept, outline the pattern of the objects in front of you. Then draw around the shadows. Notice that there are two distinct types of shadow. One is the shadow that is present on the side of objects away from the light source. This is called 'actual' shadow and is more difficult

This pen and conte drawing of a corner of a sitting room is a still life. You have a sense of the occupants of the room without them being visible. What makes this drawing particularly interesting is the use of the bright light coming through the window, and it is as much a study of light and dark as it is a study of particular objects. The composition would have an entirely different quality if the source of light was from *a small table and the fire, or passing directly over the viewer's shoulder from an unseen window. Any alteration in the position of the light would place a different emphasis on the composition. If the light, for example, was coming from a window on the opposite wall, the apples, scales and occasional table, would be brilliantly lit, and the empty armchair at present in the centre of the composition would be in shadow.*

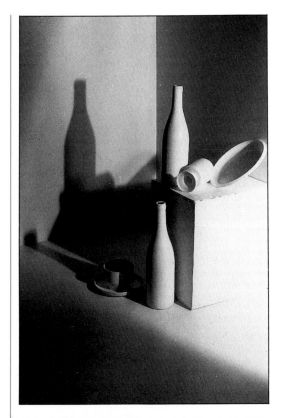

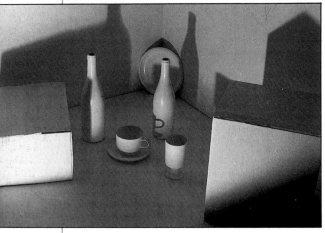

In the four photographs we have ordinary domestic objects which have been painted white, and in each photograph the single source of light has been moved, giving each photograph a different two-dimensional pattern of lights and darks.

The relative positions of the objects to the camera has not been altered in each of the photographs.

to see, particularly on a cylindrical or round object, as the dark side gets progressively darker, and the exact line where the greyness begins is sometimes difficult to see. Because the objects are painted white, however, this should be easier to recognize. A simple way for the beginner to draw the actual shadow is to decide where the darkest part is and shade this as dark as possible. Then decide where the lightest grey is. Divide the area between the lightest shade and the darkest shade into four, and graduate the shading accordingly.

The other type of shadows are 'cast' or 'projected' shadows. A cast shadow is that area that light cannot get to because there is an object in the way. Because light travels in a straight line, a cast shadow's shape is a version – perhaps a distorted version – of the shape of the object that is casting the shadow. Draw round the cast shadows on your still life and you will notice that there is no variation in the darkness of a cast shadow. If there is, this variation is caused by light reflected off an adjacent object and shining into the the shadowed area. Reflected light can be a very useful device and is much used by painters – discussed later.

Without altering the still life arrangement, change the position of the light, and draw the same subject matter again in the same way. Notice that all the patterns and shapes in your second drawing are very different from those in your first, although you have not moved the objects or altered the position from which you are drawing them. Make further experiments by changing the position of the light source.

Now have another look round your home and find a potential subject that is lit by a table lamp or a single light source. Set yourself up to make a drawing of it. The first thing to notice is that because all the objects in view are not white but their rightful colours it is much harder to see the shadows – although even on a black telephone the lights and darks are still there. The part of the telephone turned away from the light is a blacker black than that part of the telephone turned into the light.

So in drawing as a method of recording, considerable clarity is required. Think of your sketchbook more in terms of a notebook or reference book. For example, if you do a study of a child's bedroom, and then of a child at a different time and probably in a different situation, the drawings in your sketchbook should be sufficiently clear in the information they hold to enable you to combine the two drawings together and make from them an interesting painting or drawing. Professional artists look through their old sketchbooks to find a suitable tree, boat, car, or person, that they need for inclusion in a composition. Unfortunately the word 'sketch' seems to indicate something hurriedly and indecisively drawn.

Try not to restrict your drawings in a sketchbook to scenic compositions. Careful studies of wild flowers, rock formations

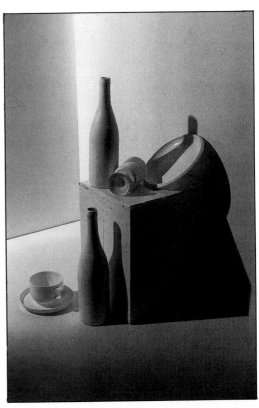

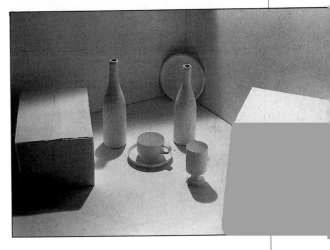

and all manner of natural forms may be exceedingly useful to you. Also make studies of cars, bicycles, windows, doors, people, and animals. Many people are restricted in the time of the year at which they can draw and paint, and the visual information on flowers gathered at the height of summer can be crucial to the successful completion of a landscape painted or drawn at home in the depths of winter. Flower painting and drawing offers enormous possibilities, and it is often the desire to use colour that makes this subject most attractive. However, many beginners' paintings of flowers rely on an exuberant use of colour at the expense of form.

Drawing flowers without the use of colour might at first seem not to be a very rewarding pursuit. The necessity to concentrate on the form or construction of a flower is, however, well worthwhile. A flower is not a haphazard splash of colour but a construction of a series of delicate shapes. A well handled drawing of roses can give the viewer all the impression of colour and delicacy of form. Some varieties of wild flowers, such as the thistle, have a sculptural and pictorial quality that makes them ideal subjects to be drawn as a separate entity and unrelated to other objects. All flowers and plants are very worthwhile to draw because they demand great sensitivity and observation; for the student who is particularly attracted to working in a detailed way, the possibilities are extensive.

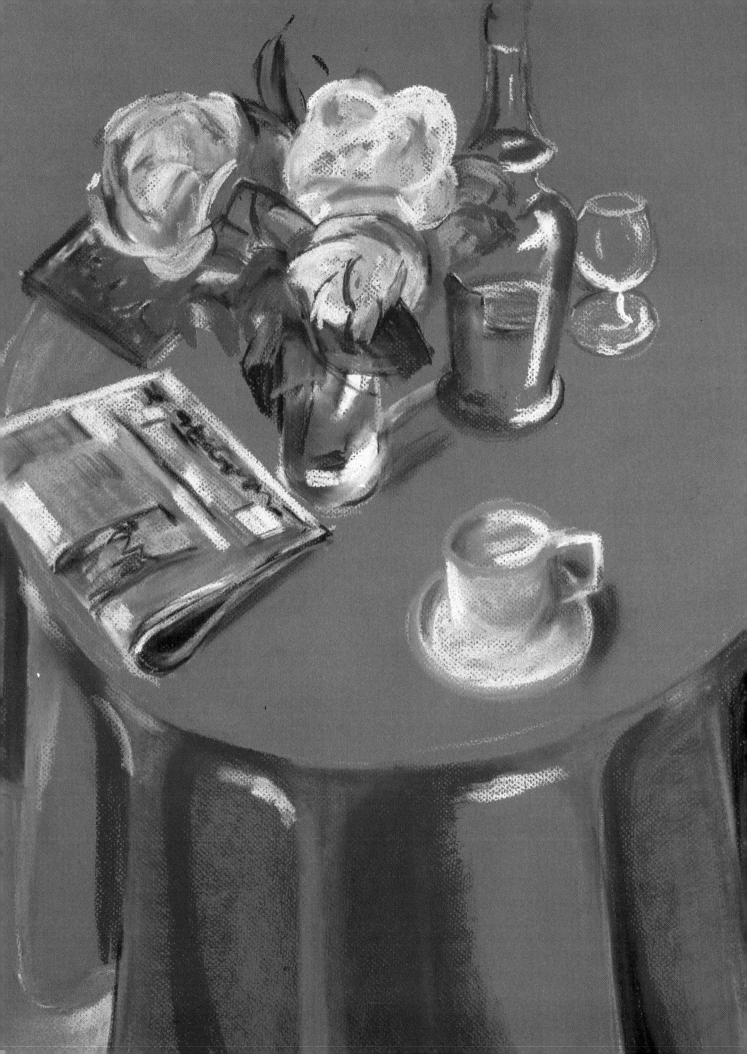

It is possible to make interesting studies of butterflies and other insects, and of vegetables and fruit. A still life of vegetables can be greatly enhanced by the inclusion of an appropriate insect. Again, if a drawing has been previously collected in your sketchbook, the inclusion of an insect in your still life will be visually convincing.

This is one of the most difficult things for the beginner to fully understand: how to draw the difference between a dark colour and a dark shadow. There have been a number of conventions that have tried to solve this particular problem, but the advice normally given to a beginner is to treat these two visual phenomena separately and to avoid in any one drawing a rendering of both shadow, and light and dark colour.

A piece of charcoal can only make a dark shape. In other words, it can only be monochromatic, it cannot make colours. However, a student faced with the problem of drawing a dark green bottle next to a pink box with dark pink lettering on it will

LEFT AND ABOVE LEFT *The subject matter is the same, but each artist has handled it in an entirely different way. The pastel drawing on a blue paper is executed in a bold and free manner, and the amount of detail has been kept to an absolute minimum. The character of all the objects on the table is suggested rather than defined. The pencil study of a geranium on a round Arabic table is sharp and clear with the minutest detail being recorded. A sense of colour is achieved by variations in the light and dark of the pencil hatching. In this study there is great emphasis on the overall textures of all the objects being drawn, and although there are shadows suggested, there is no clearly defined direction of the light source. The variations in value on the leaves and flowers suggest a variation in their actual colour rather than the existence of a cast shadow.*

RIGHT *This fine pencil study of a table displaying objets d'art shows a far greater interest in the two-dimensional pattern that the objects create than it does in a photographic description.*

ABOVE *The beginner often finds it difficult to recognize potential subject matter, particularly in surroundings which are completely familiar. This pen and ink study of an armchair by a window must be typical of thousands of homes; such a subject can be treated in a variety of ways. Here, the artist has chosen to concentrate on all the different patterns to create a very two-dimensional image.*

draw the bottle and the lettering on the box with the same intensity. When just using pencil, charcoal or ink, there is no way to show that dark pink and dark green are very different colours. Added to this is the problem that the light is causing one side of the box to be much darker than the other – that is, one side in actual shadow – and that the bottle is between the light and the box, thereby casting a shadow across the box, all of which the student is trying to show with a pencil or charcoal that makes only a monochromatic mark.

It is evident that all these different variants of light and dark on the objects can be very difficult to express clearly in one drawing. Artists have various personal methods of recording these visual differences. The most commonly used method to express colour is to treat colours monochromatically in terms of their tonal value. A two-dimensional drawing or painting is made up of flat patterns. These patterns can be caused by the shapes of the objects as well as their colour. Now to express their shape we know that we can use a line. To give an indication of colour, all you can do in drawing is to indicate the lightness or darkness of the colour, rendering your drawing as a series of flat tonal shapes. Actual shadow and cast shadow in this instance are seen as a variation of colour on the object.

All this information in one drawing has a tendency to flatten out the three-dimensional quality of the objects being seen. To express the three-dimensionality of an object and create an illusion of depth, it is often an advantage to ignore variations in colour, and to restrict your drawing merely to showing the light and dark areas caused by actual and cast shadows, because it is the shadow on an object – and the shadows it casts – that make for the realization in a viewer that the object is round or flat. If this is done successfully, the viewer's mind can 'assume' the missing tonal values of colour.

Sculptors in particular tend to draw using this light and dark method, creating the added illusion of space by atmospheric perspective, as their concern is more with mass and form than it is with colour. Drawing has primarily been used by artists as a means of visually recording what they have seen for use in their studios at a later time. For these drawings to be of any real value as a starting-point for a future painting the information in them must be of such clarity as not to be visually misleading. Raphael, the great 16th century Italian Renaissance painter, used many of his figure studies on more than one occasion in different paintings. His drawings were so clear in the information they held that he could give a drawing to an assistant to use as a reference for a figure in a painting. Cézanne, in the latter part of his life, was using life studies done many years earlier when he was a student as visual reference for the series of paintings of bathers in a landscape.

FIGURE DRAWING

LEFT *A craggy, older face is often much easier for the beginner to draw, as there are many areas, particularly round the chin and eyes, which can be drawn in a linear manner. This is simpler to understand and represent than the smooth contours of a child's face.*

A costumed figure drawn in pencil; notice the shape of the collar and the back of the shirt in relation to the neck, and the way in which the collar is being pulled away because the head is leaning forward. The trouser leg is taut at the back where the calf is pushing and the folds are being pulled to the front. The folds round the arm of the shirt clearly show the elbow. This quick study clearly shows that there is a body inside the clothing.

*F*IGURE DRAWING obeys the same basic rules of drawing as for any other subject matter: the problem still consists of translating what is three-dimensional onto a two-dimensional surface. But to most beginners, and even to artists of some experience, the problem of drawing the figure appears to be insurmountable. It is often incorrectly thought that the artist requires years of detailed anatomical study and of practice in drawing the figure from life before any satisfactory result can be achieved. This tends to make beginners avoid inclusion of any figure in their drawings and paintings wherever possible. Children, however, are in no way inhibited when it comes to making a representation of their parents, brothers, sisters, or teachers, and they quite freely make images of people which, although not photographic images, can be stunning observations.

To introduce yourself to drawing the figure, do not at first try to make an accurate representation as you might do in Still Life. Accuracy of observation is certainly still required, but for drawing the figure the student must begin to develop a visual memory. Unlike Still Life, the human figure is animated and moving for most of the time, so some system of retaining and then recording the particularities of people is required. The character of a person is seen not only on the face but also in the way in which he or she stands, walks, and moves the arms and head. Someone who is reasonably well known to you can be recognized from behind by the way in which he or she walks.

First practise drawing matchstick figures – but instead of drawing them in a childlike fashion, start considering where the joints of the arms and legs actually are. In this way, by observing people in their everyday activities and translating them into matchstick figures from memory, you will learn two of the most important elements in successful figure drawing. You will extend your visual memory and you will develop an understanding of animation. Artists such as Lowry developed the matchstick figure to a very high level of expression. On close examination of any of his paintings, what at first appears to be a matchstick figure turns out to be a highly animated individual, with very little reference to any particular anatomical feature.

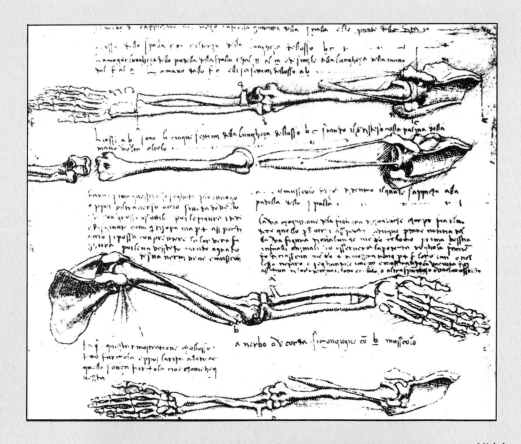

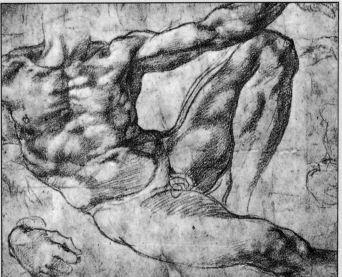

LEFT *Michelangelo's study for the torso of Adam which he drew in preparation for his work in the Sistine Chapel; although Michelangelo had a profound understanding of the anatomy of the human figure, he never let this knowledge get in the way of his artistic expression. In the finished work, where Adam's hand is receiving a bolt of lightning from the hand of God, the anatomical detail has been reduced to a minimum so that the eye is not distracted.*

LEFT *Da Vinci took his study of anatomy much further than many of his contemporaries, and his drawings and written notes have the precision of medical scientific journals. His approach to anatomy was used for many years in the teaching of anatomy at art colleges. It is only comparatively recently that the study of anatomy is no longer obligatory.*

RIGHT *In this caricature of Bernard Shaw, those parts of the face and head which indicate character have been exaggerated. The intellectualism is expressed in the large dome-like forehead. The rugged ears and ferocious glare suggest his celebrated acerbity.*

A fine pen and ink study by Albrecht Durer in which the hand and the face are defined by individual lines that follow the direction of the form. This is particularly noticeable under the left eye where the lines echo the curve of the eye ball behind the lower lid. Drawing self portraits, including hands, is one of the most useful exercises for the beginner.

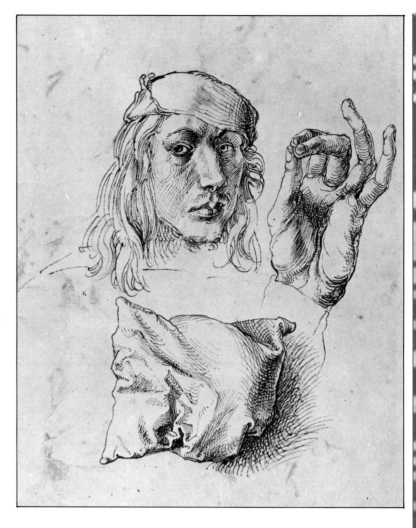

ABOVE *Pen and ink sketches; the thick black swathes of ink give the figures an appropriate solidity, and the features, although exaggerated, do not quite become caricatured.*

This approach is not dissimilar to that revealed in Aboriginal cave paintings, in which each individual character in the hunt can be seen playing an individual part in the action.

To help understand the way in which a figure is animated, it is useful for most beginners to make themselves a figure out of pipe cleaners and a bit of modelling clay, or obtain an artist's lay figure. By articulating the arms and legs where the joints occur, the figure can be set in a great variety of poses. It is usually obvious if the pose in which you have set the figure is incorrect. When satisfied with the pose, draw the matchstick figure from various angles. In this way, an understanding of how the arms and legs work in conjunction with one another can be appreciated. (You will probably find this exercise more difficult than you thought.)

After some practice, get a friend or member of your family to sit for you in as natural a pose as possible. Unprofessional models tend to be a little stiff and formal. Do not expect them to sit still for more than about ten minutes at a time, for it can

LEFT *This delightful pencil study captures the round softness of the child's face. The form of the cheek has been further enhanced by lighting the subject from the top right hand corner, and the soft suggestion of shadow under the cheek, gives that part of the face a fullness you would expect in such a young child.*

ABOVE *Self portrait in charcoal; this is never an easy subject to tackle, but it is a marvellous exercise for any student. Try and make your self portrait as interesting as possible by lighting the face in an imaginative way.*

become very uncomfortable and you could lose a potential model (and perhaps a good friend). After all, people are living and moving subjects, and you cannot make them static, like objects in a Still Life.

Working quickly, do a continuous line drawing in the same way as you would draw a tree. Do not try to draw the figure in its individual parts but draw the figure as a whole outline shape.

Our perceptual problems with the figure are far greater than they are with any other subject because we constantly refer to and think of people and ourselves in terms of the individual parts that make up the whole. We tend to think of somebody in terms of having a lovely face, nice hands or big feet, as though these elements are totally unconnected with the person as a whole, because we appraise them as individual parts. This makes it difficult to get the individual parts in the correct proportion to one another when drawing the figure. For example, we naturally place far more importance on the head and face than we would on the feet or arms, because we communicate

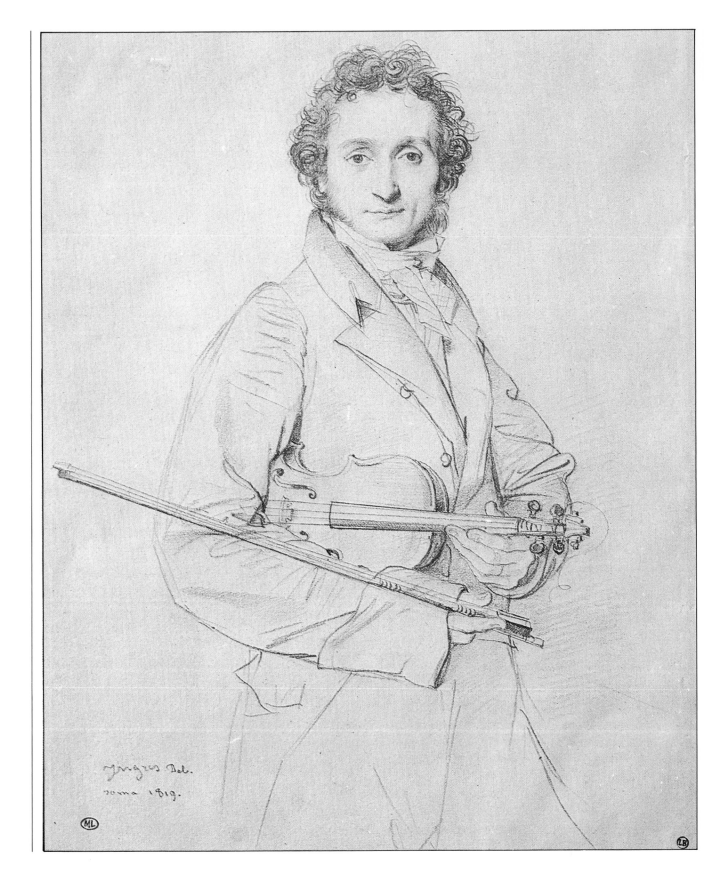

predominantly with the head and face. Every beginner therefore tends to draw the head proportionately much larger than it actually is. This can be seen in a child's drawing, in which the body of the figure plays a very secondary role. It is quite easy for most beginners to see that all the elements in a Still Life are equally important when making a representational image of them. It is, however, much harder to overcome our preconceived knowledge of the figure, and this makes representational drawing of the figure much more difficult.

Most of our experience of the figure takes place in a fully clothed situation, and it is sometimes difficult for the beginner to fully appreciate that inside a jacket sleeve is an arm, and about half way down the arm an elbow joint, and so on. Yet although it is helpful to draw from a nude model, it is by no means absolutely essential. If a life class or a life model is not immediately available, ask a fully clothed friend to pose – but instead of drawing him or her articulate your pipe cleaner

OPPOSITE *This beautiful pencil portrait of the virtuoso violinist and romantic composer, Paganini, was drawn by Ingres in Rome in 1807. The head is well defined with the minimum of lines, but each one is used to stunning visual effect. With the minimum of tonal shading the firmness of the brow and the softness of the mouth and cheek are expressed. The rest of the drawing is more loosely drawn which gives an added* *sense of life and movement. The hands are supremely elegant. The beginner could do well to copy this drawing and then attempt to draw a portrait of a person in a similar style.*

ABOVE *This uninhibited and delightful pen drawing by a thirteen-year-old of his brother makes few concessions to anatomy but it is expressive of the character of the sitter, even though he is drawn from behind.*

TOP *A quick conté drawing of a sunbather; notice the direction of the lines under the top of the right arm which indicate the plane that the figure is lying on.*

ABOVE *For the beginner, it is helpful if the image is seen in the simplest possible terms. Try to draw the first statement as simply as possible. With practice, recognition of negative and positive shapes will become automatic.*

figure or lay figure into the same pose as your model. With careful observation you will notice that even on a fully clothed figure there are many indications as to where the points of articulation take place. The way in which a trouser leg falls, or the way it folds round the knee of a seated figure, clearly indicates the point of articulation.

The next time you are in a public place, look at the people around you and make some rapid sketches in matchstick form of how the figures are articulated, making particular notes of knees, ankles, elbows, etc. For these matchstick figures really do work. Remember: the points of articulation must be in the right relationship and proportion to one another.

For the beginner, it should be stressed that the most important areas of anatomy to be studied are the points of articulation, as discussed above. Unless a particular interest is developed in drawing and painting the life figure, a detailed knowledge of anatomy is not really necessary, especially if most of the drawings you intend to do are going to be of the clothed figure. What is important is the interrelationship of the individual parts of the figure that go to make up the whole. Such interrelationships include, for example, the way in which the shoulders fit across

ABOVE *A pencil contour study of a crouching figure, the minimum of tone has been used in conjunction with a line that defines the twisting of the back. This simple gesture gives the whole figure a feeling of three-dimensionality.*

ABOVE LEFT *A pencil drawing which exploits the linear structure of the pose.*

the top of the ribcage like a yoke, and how the arms are artic-
ulated at the shoulders from the ends of this yoke; how the
pelvis is articulated through the waist; and how the spine is a
connecting column linking the head, shoulders, ribcage and
pelvis. A closer study of how all these interconnecting parts
work together can be undertaken by looking at yourself in a
mirror. It does not matter how many Latin names for the
muscles and bones that you know – in the end, drawing the
figure depends on intelligent observation and on ability to trans-
late this observation into two-dimensional form. All a beginner
requires is the capacity to perceive what is happening – not an
overcomplicated anatomical knowledge of *why* it is happening.

One area of figure drawing that has a particular appeal to a
beginner is portraiture. As an art form, however, the photo-
grapher's work has to a large extent taken over the position
formerly held by that of the representational portrait painter,
and it could be argued that a formally drawn representational
portrait has today lost some relevance.

Many modern portraits are very expressionist, verging on the
abstract, and in these works the character of the sitter is ex-
pressed in non-representational form. However, in this book

RIGHT *Notice how in this nude study the upward tilt of the head provides the viewer with one visual reference to the reclining position of the body; another is the darker line of the closest leg.*

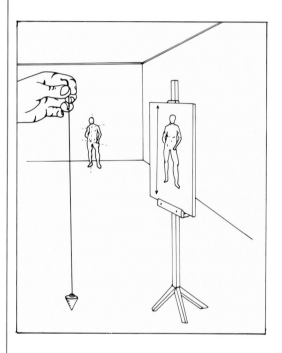

OPPOSITE *Most of the model's weight is on the left leg, which pushes the pelvis us, bending the right leg. To counteract this, the shoulders are sloped in the opposite direction. This pose was often used during the classical Greek period for both male and female sculptures. Try taking this pose yourself and study the effects on your own body in the mirror.*

This particular classical pose is most helpful in demonstrating the use of the plumb line. It is sometimes difficult for the beginner to fully realize how much a figure twists and distorts from one side to the other. By holding a plumb line, which gives a known vertical, the various angles of any pose can be more readily appreciated.

only representational portraiture is discussed. For the beginner it is more important to draw a portrait in a direct and honest manner, searching for the character of the sitter. The peculiarities of an individual's face – the difference between the left eye and the right eye, perhaps, and the realization that they are not identical – are more important to observe than the mere likeness. Even careful observation may not at first produce a truly representational drawing. Do not be overconcerned at this. It is yet again caused by the fact that it is all too easy to place too much importance on the individual elements that make up a face – the mouth, the eyes, the nose, etc. – and it is only a matter of getting these individual parts into their right relationship, and seeing the face and head as a whole.

In a child's drawing the eyes, nose and mouth are the most important features, and the eyes are often drawn right at the top of the head. Analytical observation proves, however, that a person's eyes are actually situated about half way down the face, and the nose and mouth are both in the lower half. The actual 'face' on any head is a relatively small area, but because it is the

TOP *A reclining nude drawn in charcoal; it can be seen that this drawing has gone through several stages of development until a satisfactory contour has been achieved. The whole feeling of the drawing is very sculptural.*

ABOVE *No matter how complex a figure drawing may at first appear, it is always possible to see the figure as a silhouette. Drawing one half and then the other, by arbitrarily dividing the subject at any angle, will help you to develop a sense of this two-dimensional aspect.*

area we most look at and communicate with, the beginner tends to draw the face much larger.

A beginner, starting a portrait, usually first draws an eye, then the other eye, and progressively records all the features. He or she then tries to fit the outline of the head around these features. Instead of starting in this way, make a line drawing of the head, neck and top of the shoulders; then place the other features in their correct overall positions. Observe the proportional distance from the end of the nose to the eye, and from the nose to the mouth, and represent both accurately. In this way you will notice that the head is quite a large object, and is not made up only of the obvious features. You will also notice that the skin behaves in different ways on different parts of the face. It appears tight and drawn in one part, and loose and flexible in another. The tautness is where the skin is thin and runs over the bones of the forehead, scalp, cheek, chin and jaw, and those areas that are softer are where the movement of the mouth and eyes take place.

The anatomy of the head very quickly explains its surface structure. This is one area in which some knowledge of anatomy is of real benefit. A well rendered eye depends to a large extent on an understanding of the workings of the eye. The arrange-

ment of the spheroidal eyeball within its socket ('orbit'), and the muscles that push and pull to enable the folds of skin above, below and each side of the eye to move, can be observed quite clearly on many faces. A study of the mouth is also quite important (it is all to often drawn as though the lips are stuck on and the mouth is just a slit). Again, an intelligent observation with some knowledge of anatomy soon reveals that the mouth is an integral moving part of the whole lower face, and the shape of the mouth is closely related to the size and angle of the jaw and the arrangement of the teeth. (If someone who has false teeth removes them, a great deal of the mouth and jaw line seems to collapse.)

Another area that is often poorly observed by the beginner is the neck/head/shoulder relationship. The neck is commonly

Notice how in this charcoal study the articulation of the body is indicated by the light and dark folds of the clothes; how they fall away from the knee and the charcoal lines follow their sweep toward the feet.

A B O V E *The same exercise for developing awareness of the silhouette as on the opposite page, this time dividing the figure vertically.*

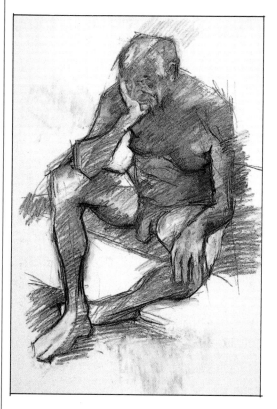

Notice the negative space between the legs and between the arm and the torso. Link those spaces with a continuous line round the outer contour of the figure and you will see that this pose can be viewed in quite simple terms. The biggest problem the beginner has to overcome is the feeling of being overwhelmed by the figure in all its individual parts. Concentrate on the positive and negative spaces and the outer contour when drawing the figure.

drawn as a stick with a ball on top, whereas in fact the neck extends to the back of the skull, approximately level with the ears. The neck and shoulders are very important in a portrait, even if they are not fully drawn, because they determine the angle and poise of the head. The poise of the head is one of the most important points to help indicate the character of the person being drawn. Very few people sit with their head dead upright, as though on military parade. Hair can also be better understood when you realize that, irrespective of how complex the coiffure, the shape is largely determined by the skull underneath. In addition, the way in which the hair grows, or the hairstyle is arranged, can be used as another visual indication of the character of the person, and can be just as important in portrayal as the eyes and mouth.

Hands can be a very important part of a portrait. The hard, marked, strong-fingered hand of a farm worker can imply a great deal about the character and life of the poser, as can the soft-formed hand of a young girl. Hands do present a number of problems in drawing; most of these are again, however, due to the way in which the hand is perceived. Although each finger has a certain expressiveness and fingers are commonly thought of individually – eg index finger, thumb – it is impossible to draw the hand one finger at a time, and it is only when the hand is seen as an overall shape, including the first three or four inches of the lower arm, that it can be successfully tackled. A tree, after all, is easily perceived as an overall shape that is made up of a number of branches because it is thought of as one object. With the hand, the reverse is true. We think of it not as one shape or object but as a combination of individual shapes or objects.

The hand, like the head, is a much larger object than most beginners think. Place the bottom of the palm of your own hand on your chin. You do not have to spread your fingers very widely to cover the majority of your face. But look at any un-tutored drawing and you will find that the hand is drawn as five very small fingers coming out of the end of the arm. The hand really begins some distance back from the wrist joint.

It is well worth a beginner's time to study the hand. This can be done by using your own hand: with the aid of a mirror the hand can be drawn from a variety of angles. Start by making a line drawing of the whole hand and then drawing into this shape the individual fingers and the spaces in between them. What generally happens when drawing the hand is that you see only two or three of the fingers at one time. Carry on drawing the hand in a variety of positions, concentrating on the whole shape. With a very limited knowledge of the anatomy of the hand, plus intelligent observation, it will not take long before you feel confident including the hand as part of the portrait.

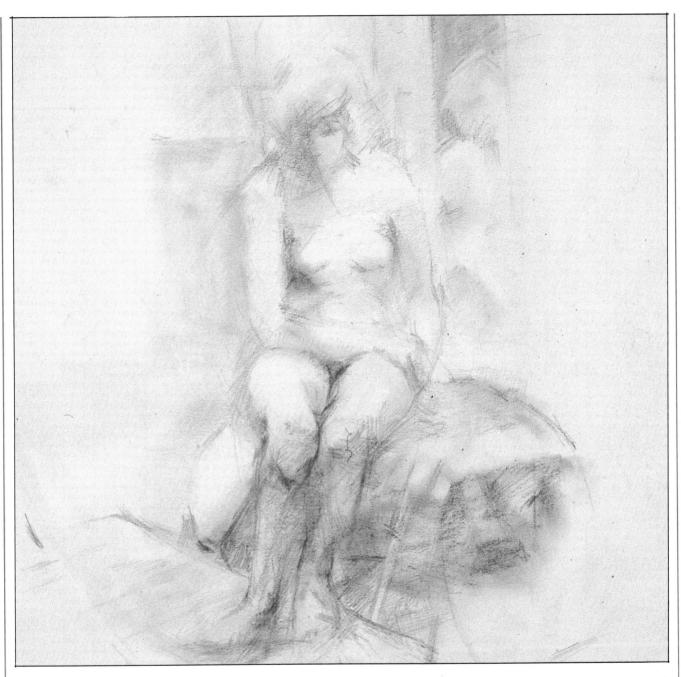

The compositional device of using mirrors can add greatly to the interest of a life drawing.

A portrait, then, is much more than just a photographic likeness. Artists have completely under their control those elements of the features they wish to emphasize and those they wish to diminish. This choice is determined by a perception of the character of the sitter and an assessment of which features help to emphasize that interpretation. A portrait can include much more than the main features of eyes, nose and mouth. Neck, hair and shoulders play just as important a part in the making of a successful picture.

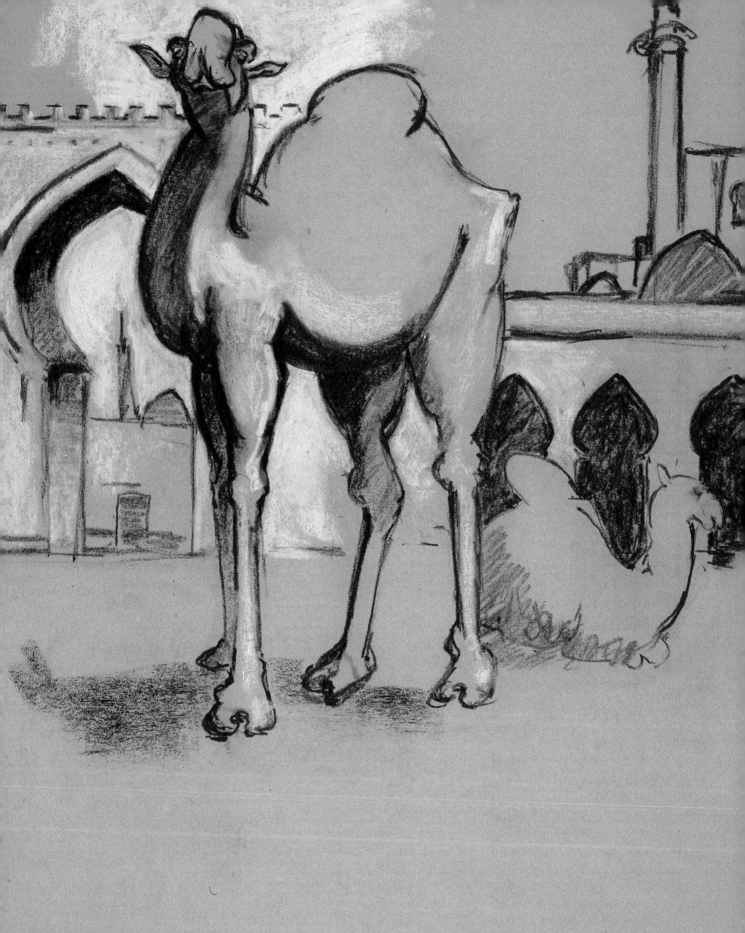

CHAPTER SEVEN

ANIMALS

Sketch book studies of camels (right) were combined with a vacation photograph to create this conte drawing on orange paper. The colour of the paper suggests the heat of the Middle Eastern setting.

Animals as subject matter for the visual arts have a longer history than any other subject. The first images drawn by the human race depicted the animals that were hunted for survival: the prehistoric cave drawings at Niaux (Ariège), in France, are some of the best preserved examples. Lions, tigers and hippopotamus were frequent subjects for wall paintings in ancient Egypt and for relief carvings in ancient Syria. There are numerous Greek and Roman examples of animal images in mosaic, bas-relief and sculpture. There is no period in art when animals have not played a major role.

In modern times, with the widespread use of mechanical transportation and with fewer people working on the land, everyday contact with animals has become more distant than at any other time in human history, so that first-hand experience of animals for many Western people comprises the particular relationship between man and his domestic pets.

Art has tended to reflect this change in social conditions with the result that many animals tend to be represented in art as cuddly and lovable, and the images are full of sentimentality. Even wild and savage animals observed at a zoo are often depicted as having all the ferocity of a large domestic cat. This has tended to turn animal representation into a secondary art form considered only fit as images for greetings cards. Our contemporary approach to this genre of painting is a far cry from the savagery and excitement depicted with such clarity in such works as the Syrian bas-relief of the lion hunt in the British Museum, London. It is not surprising that we find it difficult to draw animals with the directness with which our forbears saw them, for our sensibilities to and our relationship with the animal kingdom has changed so much.

William Blake, the 18th-century poet, engraver and pamphleteer, might give us an indication of an approach to visual images of the animal kingdom more appropriate to today. His stunning engraving of a tiger with eyes burning bright to illustrate his poem. *The Tyger* depicts a primitive savagery – but on reading the poem it is equally possible to come to the conclusion that the content is more about the conscious and unconscious

OPPOSITE, ABOVE *The White Tiger of the West guards the 7th-century tomb of Princess Yung T'ai in China; at once naturalistic (if not anatomically accurate) and symbolic of strength and imperial dignity, the flowing, single brush strokes of the image are perfectly executed.*

OPPOSITE, BELOW *An eland painted by San Bushmen of South Africa; note how large the animal is in comparison to the human figures. The eland was not merely an important source of food, but was also imbued with particular magical powers. Its relative size reflects its overwhelming importance to the artist. The white is powdered clay mixed with plant juice; the red is hematite with ox blood.*

ABOVE *Contemporary drawings of wild animals are usually drawn in a zoo environment. The animals often retain their natural dignity as this drawing amply expresses, but the full vigour of a wild beast's ferocity can rarely if ever be experienced by urban man.*

LEFT *A quick assessment of the movement of birds is necessary if they are to be drawn in their natural habitat. It is important when using this line and wash technique not to concentrate on the detail of the surroundings at the expense of the birds: all too tempting, especially for the beginner, because the terrain is static.*

ABOVE *Pen, watercolour and pastel drawing of two rhinos; this drawing was made from a series of rapid sketch book studies drawn at the zoo.*

TOP *This pencil study of a pride of lions resting in the heat was a composite of several separate sketches; the body of the lioness is actually a reversal of the lion's body, using tracing paper.*

savagery of humankind and that the tiger is used as a metaphor for the human condition. *"What immortal hand or eye/Dare frame thy frightful symmetry"* is a relevant question for today's artists, so isolated from the animal kingdom.

It is perhaps by taking this philosophical attitude to drawing the animal kingdom – portraying animals as a metaphor for the human character and condition – that it might be possible to break away from the sentimental imagery so often depicted. We are all familiar with animals being used as metaphor and in caricature by the political cartoonist, where the assumed character of a particular animal takes on the features of a person in the public eye. Many animals are associated with particular human traits – the courage of a lion, the infidelity of a monkey, and a baying pack of jackals are commonly used as metaphorical images – and they have a long history of mythological (and religious) association.

The drawing of animals presents several pictorial problems unique to the subject matter. Unlike a human, few animals obey a command to remain still. The use of a viewing-frame or squared-up paper is thus of little assistance. Even for a skilled artist the constant movement of a tiger pacing an enclosure in a zoo can present tremendous difficulties. Speed and subtlety of

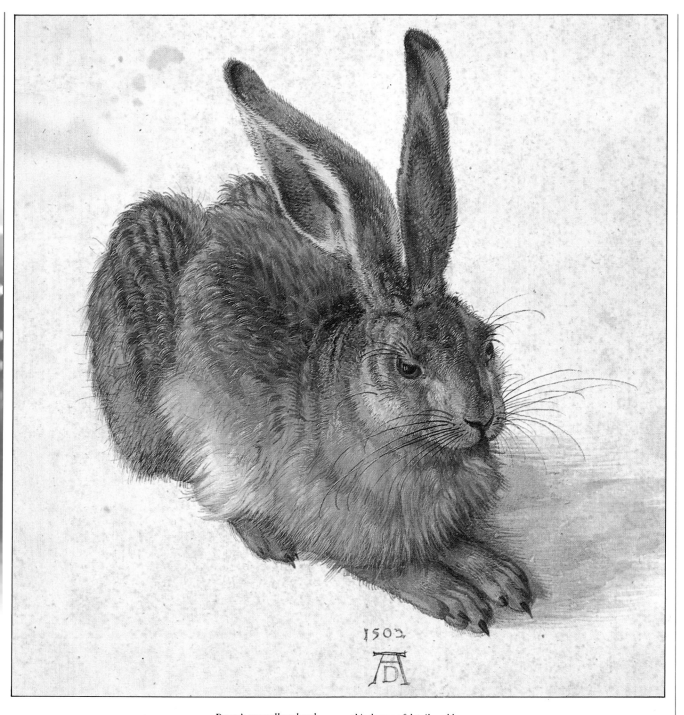

1502

Durer's marvellous brush drawing of a young hare is one of the best known of all animal drawings. It is remarkable in the detail of its observation; every hair has been faithfully recorded. In the hands of a lesser artist this degree of detail could make for a lifeless drawing, but the hare is obviously an alert, living creature. So often drawings of animals can appear to be works of taxidermy in a glass case.

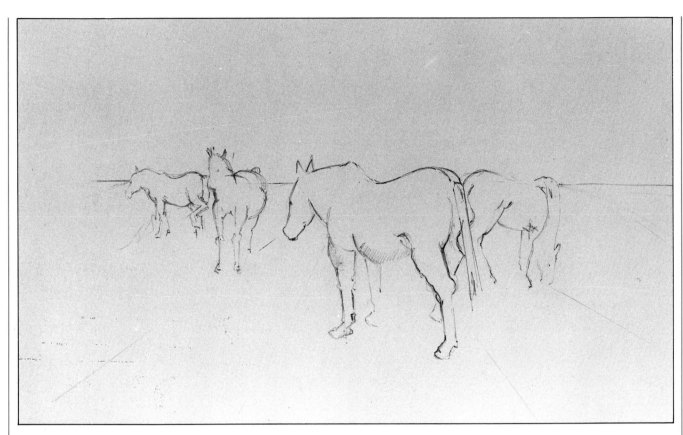

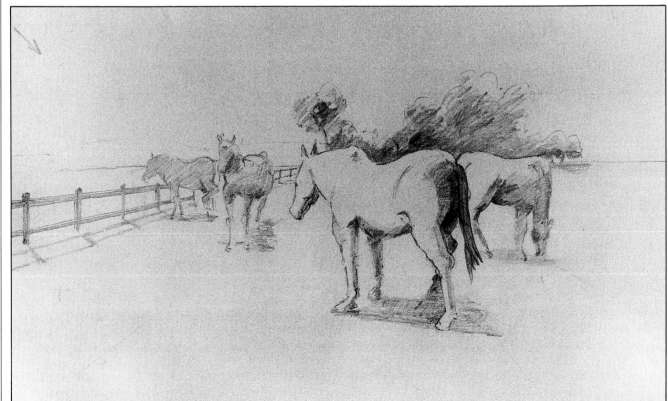

A composite sketch of horses (opposite below) made from preliminary sketches of the same horse seen from different angles; the first stage is a simple line drawing copy of the sketchbook notes arranged in an interesting way (opposite above). Notice how the eye level runs through all the horses just below the top of the neck. This ensures that all the horses are represented as being the same size.

The next stage is to decide where the light is coming from: in this case, the upper lefthand corner. This allows you to have some horses in shadow, almost in silhouette, and other horses well lit along the whole flank. The foliage in the background has been shown in shadow which alllows the backs of the horses to be clearly marked. The fence gives a sense of perspective depth. The drawing could then be elaborated further to include, for example, farm buildings if desired.

observation are required to draw animals in this environment. Before any attempt is made to put pencil to paper, therefore, observe the animal for some time – how it moves, the size of its head, the proportion and weight of the limbs – and then with the animal in front of you create a drawing that is made as much from your visual memory and imagination as it is from direct representation. When the beginner first tries to draw animals at the zoo, he or she should try to arrange that the time spent there includes feeding time. This is the one time when, although the animals are no less active, they are more generally in one place. The drawing of birds often presents even more of a problem, although they can be drawn quite easily when they are resting on a perch. When they are in their natural environment, or in flight, however, to represent birds as members of a recognizable species is a skill that only an ornithologist is likely to develop.

A charcoal and gouache study of a resting leopard; no actual sketch was made of a leopard in this particular pose and it is a composite of snatches of visual information hurriedly drawn. In a zoo, even when animals are reasonably relaxed, some are almost constantly in movement.

For those who wish to become deeply involved in this fascinating subject, some basic understanding of anatomy is a great help. For example, a knowledge of the pelvis and leg bones of a horse enables the beginner to understand the shapes visible on the surface of a horse's flank. As in drawing the figure, the points of articulation are the most important anatomical features to be aware of, and much useful work can be undertaken towards an understanding of animal movement by studying individual species at a local natural history museum. A simple book on animal anatomy would help if there is no easy access to real skeletons in a museum. In general, it is probably better if you try not to make drawings that are mere anatomical studies, but concentrate on the visual responses you experience as an individual to each particular animal.

Most drawing media are suitable; selection really depends on personal choice. The speed at which charcoal can be used with little pressure perhaps has a certain advantage for the beginner.

Photographic reference may also be of some help but should, if possible, be used in conjunction with visual notes made in the presence of the animal that is to be drawn. It does not matter how good or faithful to life the photograph of a tiger might be, there is no substitute for the first-hand experience of seeing the sheer power and size of a fully-grown tiger on the move, even in a zoo enclosure.

If photographs are to be used, it is far better to use photographs that you have taken yourself, for they will act not only as a reminder of the visual appearance of the animal, but they will also remind you of your own feelings toward it.

TOP *This drawing on pale yellow cartridge paper in pen and gouache was made from the small sketch in the bottom right hand page of the sketch book. The sketch was reversed by taking a tracing and transposing the image onto the paper.*

ABOVE *Pencil studies of leopards and lions.*

CHAPTER EIGHT

NATURAL FORM

LEFT This pencil study of a vase of daffodils and foliage shows a very different approach to the one on this page. It has not been drawn to identify a particular plant but is much more concerned with the vibrance of the lights and darks.

URING THE 18TH CENTURY the great voyages of discovery in search of new lands were also linked to serious scientific expeditions to record the natural world. This required totally new forms of drawing. The demands for accuracy of representation required by map-makers and others formed a relationship between the mathematician, the natural scientist and the artist. This then new demand for accuracy of observation naturally spread to the recording of plant life, animals, birds, insects, geological formations and topographical landscapes.

One artist might be required to draw all manner of subjects, and it was not until much later that even more specialist artists, who concentrated on a single theme (such as botanical drawing), were employed. This development was brought about by the division of the scientific community into specialist fields, and to this day there are courses available to train specialist artists – for example, medical illustrators to graphically portray aspects of surgery and other medical fields for textbooks.

Great accuracy in representation is required irrespective of the specialist subject being drawn, and a type of drawing that dispenses with any visual information which in any way might confuse is essential for the accurate recording of natural form.

This type of drawing also demands a clarity that can be easily translated into print, and from early on it was found that pen and ink or hard pencils produce a clear and definable line, the results of which are highly refined and delicate drawings. In studying reproductions of beautiful 18th-century botanical drawings, framed and gracing the walls of a modern suburban home, it is often not realized that these drawings were carried out for scientific and not for decorative purposes. So great was the artistry of their creators, that the work they produced possesses such sensitive and delicate visual beauty, particularly considering the arduous circumstances in which many of the originals were drawn.

For the contemporary student there is now available a whole range of reservoir pens that produce a very fine and even black line; one of these pens will be found most useful. The fact that ink cannot easily be erased encourages careful consideration

ABOVE A student drawing in the style of an 18th-century botanical study. The fine watercolour wash and written notes help identify the plant as a particular species. The snail eating a leaf adds a further touch of graphic interest. This is the type of drawing an illustrator would produce for a book on gardening or something similar.

Still Life with Chair,
Bottles and Apple;
*Cezanne used still life to
explore the relationships of
forms and their interation
on various spatial planes.*

RIGHT *A study of daffodils
in pencil and oil pastel; the
diagonal application of the
colour helps give this simple
composition visual
excitement.*

before any mark is put to paper, but with practice drawings can be effected with great speed and accuracy.

Many beginners start by making a pencil drawing first and then inking over this primary study. Although the student may feel this is a safer way to proceed, the end result can be disappointing, for the inked line inevitably looks very dead. This is due to the fact that the student is no longer looking at the subject matter when inking over the pencil line with the pen; in many cases, therefore, it would be much better if the student left the drawing as a simple pencil study. Really, it is essential that you develop the confidence to use the pen directly – there are no easy shortcuts.

Start by taking a single flower and recording all that you see as accurately as you can. Turn the same flower to another aspect and draw it again. Take the same approach with insects, fruits, vegetables, leaves or any natural object that catches your eye.

RIGHT *This plant study in charcoal displays a linear approach with no attempt at shading. The fineness of the line has been achieved because the study is larger than would normally be expected of a plant drawing.*

It measures 38 × 27 in (95 × 68 cm) which allows sufficient space to use charcoal in a linear manner. Although not an impossible medium for plant drawing, charcoal is not suitable for detailed studies.

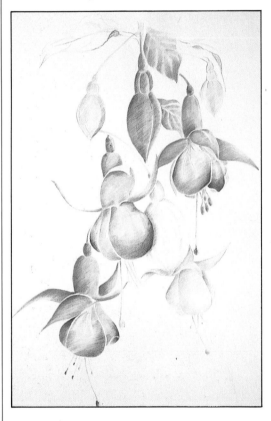

ABOVE *Fuschias drawn in pencil and wash, reminiscent of the elegant style of the botanical draughtsmen of the 18th and 19th centuries. The work is, however, more concerned with formal beauty than it is with plant recognition.*

For the student wishing to study natural form beyond a passing interest, a large (naturalist's) magnifying glass and stand is a necessary piece of equipment through which to view the fine structures of the objects being drawn.

Such an analytical approach to drawing natural form some students might find too restrictive for their own personal approach, and indeed objects of natural form can be drawn in a more expressive and personal manner. Works that divert from the scientific and analytical approach are nearer in content to Still Life, which allows the student much greater freedom both of expression and material resources. A painting such as Van Gogh's *Sunflowers* is essentially the same subject matter as an 18th-century botanical drawing, but the purpose behind the Van Gogh painting could not be further removed. Van Gogh's rendition of *Sunflowers* was an expression of his personal feelings and was not intended as an analytical study of the plant species.

A fine pen is used to make fine marks – but now take a flower or other plant form and draw it in charcoal. It is soon evident that a charcoal drawing would be unsuitable for botanical recognition, but that charcoal is ideal for expressing the growth and virility of a plant, or expressing the abstract pattern created by plant form.

Something must be said at this stage about the use of colour in representing natural form. Although very interesting drawings can be made in black and white, the importance of colour cannot be totally ignored in this particular area of study. Water-colour wash was used in almost every work by 18th-century

artists because colour is so important in the recognition of species. The student may wish to try laying some simple washes on a pen or pencil drawing.

Other useful media are pastel – both dry and oil pastels – and coloured pencils, with which the riot of colour in nature can be recorded in a more forceful manner than watercolour wash normally allows. In art schools, the drawing of natural form has long been associated with mixed media, and a combination of pencil and oil pastel can result in some very exciting work. Ink and gouache also work very well together. One of the great advantages of drawing natural form is that it enables the student to experiment more freely and without inhibition with a range of materials that might create difficulties if used in drawing landscape or the figure.

Try not to be too selective in your subject matter – some of the most exciting works constantly cross the artificial boundaries that have been set up between still life, natural form, animals, figures, and so on. It is preferable that the student treats every-thing that is or has been living as a possible subject. A study of the rocky face of a cliff or of the delicate legs of a garden spider is of equal visual interest. It is not the subject matter that turns a drawing of a cliff face from a landscape to a study of natural form, but the artist's approach to the subject. The landscape artist is more likely to be primarily concerned with the atmos-pheric quality of light and colour, linear structure is normally of secondary importance, and colour is used descriptively. In the drawing of natural form, it is the structure and physical com-position of the object being drawn that is of primary import-ance. As with so many things in the visual arts, it is the approach that the artist takes toward the subject matter, not necessarily the subject itself, that classifies the work as of a particular genre.

Again it must be stressed that unless the student specifically requires to work within the boundaries of a particular genre it is better for the beginner not to be overconscious of what consti-tutes a particular type of work. It is more useful to the beginner to let the drawing develop in a natural, creative way, using whatever medium seems suitable at the time. Do not limit your-self with unnecessary restrictions. The artificial classifications of different types of work are only necessary in cases where a professional artist has received a brief or commission to carry out a piece of work for a predetermined result, such as an illustration for a gardening book or a descriptive drawing for a textbook on biology. In these cases, the brief would be clearly written to describe the type of illustration required. Unless the student intends to study to a professional level, this approach to drawing can inhibit a student's natural creative growth and enthusiasm, which in the beginning are far more important to develop than are professional attitudes.

This pen and ink study has been produced as a two-dimensional abstract design, and although it is a drawing of a plant, the manner of its composition makes it much more an exercise in still life than an accurate representation of natural form.

DECORATIVE ARTS

*T*HE STUDY of natural form leads irrevocably to the applied arts, in which the motifs of natural objects are the predominant subject matter. Look around any home and you are almost certain to find curtains, wallpaper or furnishing fabrics that in some way use leaf or flower patterns, originally inspired by and derived from studies of natural form, irrespective of how abstract these patterns may have become thereafter.

The use of natural form motifs in the decorative arts crosses the most diverse of cultural boundaries. The stylized Japanese willow pattern, so desired for domestic table ware, is an excellent example of the use of natural form and landscape for decorative purposes, as are the leaves and scrolls used to decorate wrought iron gates and screens. Indeed, when natural form is used in the decorative arts it is normally presented in a stylized or formalized manner, and this results in a discarding of much of the finer detail and accuracy that would be necessary in a botanical drawing. What remains, for example, is the broad sweep and graceful line of a lily or a swan. Such generality is necessary, for if the swan had too recognizable an individuality in the eyes of the viewer it would make for the greater concentration on a single image at the expense of the overall effect of a repeated motif. If a fabric, for example, is printed with a repeated pattern in black and white, and the white part is in the form of a swan, the overall decorative effect of a draped length of fabric should be of a black and white design in which the importance of the black negative shape is as great as the white positive shape.

In the decorative arts the visual significance is far more in the overall pattern than in the individual recognition of objects, and it is through the decorative arts that a beginner can gain firsthand experience and understanding of abstract images.

The stylistic approach of the *Art Nouveau* movement of the late 19th and early 20th century shows some wonderful examples of the use of natural form in the decorative arts. This particular style affected all areas of the visual arts from architecture to fabric design, electrical appliances, wrought ironwork, couture fashion and furniture. It was one of the first styles to be purposefully created that directly affected, in such a broad

Tiles from Iznik in Turkey, mid 16th-century, made for the embellishment of mosques and palaces. Designs on paper were provided by court artists in Istanbul and faithfully transferred onto tiles at the Iznik potteries.

ABOVE *'Michaelmas Daisy' wallpaper designed by Morris and Co., first produced in 1912. There is an indefinable beauty in repetition: you need not, of course, attempt such an intricate design if you wish to produce your own stencil or decorative border.*

ABOVE RIGHT *A Morris tapestry of 1885; the natural world is the inspiration, but the depiction of the plants and birds is simplified and subservient to the overall design. It is the pattern of line and colour which predominates.*

BELOW RIGHT *Dionysus and dancing girl from Ancient Corinth; all decorative art that is essentially linear, no matter what the medium, is essentially drawing.*

manner, all sections of society at more or less the same time, and it is interesting to note that the later geometrical styles so associated with modernism have not had the universal appeal over such a long period as the abstract natural form of Art Nouveau. The following, interlacing rythms and lines of Art Nouveau give a sense of the growth and rythmic movement of natural form.

The applied arts, by the necessity of modern manufacture, are divided into very specialist areas; the skill of a designer of printed textiles is very different from that required of a ceramicist. Each branch of the applied arts may take many years of professional specialist training. In this book we touch only very briefly on those areas which are likely to be of some interest to the beginner. The skill of the fabric or wallpaper designer is to take a motif as unruly as climbing ivy and to organize it in such a way that it endlessly repeats itself and can be matched along a seem or join. This is achieved by designing the pattern on the basis of a grid, a grid that then continually repeats itself. This is often referred to as the 'drop' in the pattern, a term that may be familiar to anyone who has done any paperhanging.

The simplest drawing medium was first used by prehistoric Man when he took a piece of burnt wood from the camp fire and drew the animals he hunted on the walls of the cave. Examples of these drawings exist to this day as testimony to the suitability of this medium for drawing. Charcoal, as used in art today, is produced in an airtight kiln in which willow and vine twigs are taken to a very high temperature; each twig retains virtually the form it had when it was alive.

It is by nature an inert material and is very easy to remove from the paper or smudge. Both these qualities may seem a disadvantage at first, but there are many artists who use these very qualities as an integral part of their drawing technique. To spread charcoal, fingers are the most useful of tools for large areas. For more delicate tonal graduations a hog's-hair brush or a torchon, which is a stick of tightly rolled paper sharpened at the ends, can be used. Both tools allow greater control than the fingers. Tonal highlights can be brought back to the full brilliance of the paper with a soft putty rubber, or a piece from the centre of a slice of fresh bread rolled in the hand to make a small dough-ball, which lifts the charcoal very effectively off the paper.

White drawing chalk or white pastel can be used in conjunction with charcoal to give another range of intermediate greys. Two relatively recent developments in charcoal are the charcoal pencil and the compressed charcoal stick. Both media tend to make a more consistently black mark than natural charcoal, and although they have a distinct advantage when working quickly out of doors, the added density constitutes rather a disadvantage if very fine tonal graduation is required, for there is a

certain stickiness which can make this particular form of charcoal less flexible.

Conte crayon is thought by some to be an alternative to charcoal. However, on the paper it behaves in an entirely different way. It is available in stick and pencil form, and also in a variety of colours, but it is traditionally thought of as black, white, grey, red and brown. Although it can be spread with a torchon or finger, the sticks are held together with a slightly greasy gum which makes them less flexible than traditional charcoal. It cannot be erased, so considerable confidence is required to use this medium successfully, but the density of the black is itself useful in producing drawings in which high contrast is required. The range of greys, all the way to white, now give this medium the possibility for use in delicate tonal studies, particularly when drawing from nature where the tonal information being collected is to be used as a study for a painting.

A beginner who is interested may make a first attempt at creating a pattern by trying to design a frieze or decorative border. Draw a simple leaf motif that repeats itself every six inches. This will require you to draw the motif in such a way that the beginning and the end of the pattern match, so that the whole motif repeats itself in an uninterrupted and continuous flow. After four or five attempts you will probably end up with something reasonably simple and quite attractive, a pattern that could be cut out and used as a stencil to personally decorate furniture or a room.

A further introduction to the decorative arts can be made through the use of specialist enamel paints for ceramic decoration. Take a plain white plate and in the centre quite freely make a decoration of flowers or fruit. (As long as the plate is going to be used only for decorative purposes it is not absolutely essential that the ceramic ware is fired in a kiln. However, unfired decorated tableware should never be used domestically.) There are many fine examples of folk art comprising utilitarian objects such as steel jugs, bowls and plates that have been brightly decorated with ordinary enamel paint and preserved as decorative objects.

The superb results that can be achieved in such fields as ceramics and fabric printing often come as a surprise to beginners, who can sometimes get started after the minimum of training at an institute offering part-time classes. It is certainly recommended that students interested in the applied arts should avail themselves of some basic course. It is not impossible to learn silk-screen printing or ceramics (for example) through a textbook, but both subjects require a considerable amount of specialist equipment, and it would be a pity to make a mistake in the choice of equipment because of limited knowledge and experience.

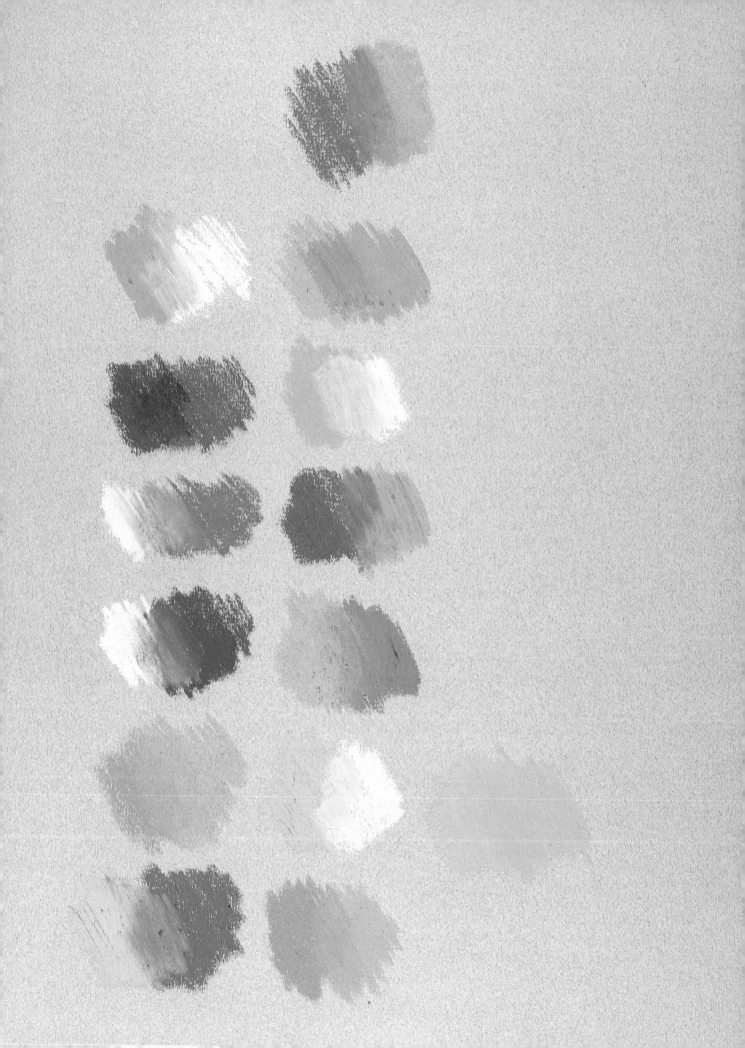

MATERIALS, EQUIPMENT AND PRESENTATION

LEFT *Oil pastels are an adaptable medium; the colours can overlay one another or can be blended more completely with the fingers.*

*I*T IS RECOMMENDED that a beginner keeps the materials and equipment as simple as possible. Modern chemistry and technology have produced an incredibly wide range of new media totally unknown to the Renaissance artist. These appear extremely attractive to the beginner, who feels that wonderful results are bound to spring from these apparently easy-to-use materials. Nevertheless, until you are reasonable confident it is to your advantage to work mainly with the traditional materials that behave in a manner that can be anticipated.

With natural charcoal a variety of papers can be used – but for the beginner a medium-toothed hot-pressed paper will probably secure the best results. The heavier-toothed papers require a little more confidence as the marks are smudged and moved less readily. Compressed charcoal and conte can be used on a grained (toothed) paper, but some of the quality of hard, black line which these media can make is lost. If the drawing is intended to be predominantly linear, a harder-surfaced paper is more suitable. Some very interesting drawings in Conte can be produced on a common, hard cartridge paper; that medium produces marks that are slightly greasy and do not require a toothed paper to adhere to the surface.

With all these mediums, coloured papers specially produced for charcoal and pastel drawing can be very helpful. The coloured papers can reduce the starkness of black against white, if such a contrast is not required.

Pastels behave very similarly to charcoal and conte, and come in a variety of grades from very soft to a stick as hard as a 2B pencil. Many beginners find that their first approach to colour is through this medium. When using pastels care should be taken in the selection of the paper. With the harder variety of pastels, which behave more like crayons, a hard, smooth paper can be quite suitable and a very clear and detailed image can be produced. With soft pastels, a paper with a tooth (grain) is almost essential for a satisfactory result because the tooth of the paper is necessary to hold the soft pastel marks. (If soft pastels are used on smooth paper, as fast as the pastel is put on the paper it will come off, because there is nothing to hold it.) There are a

ABOVE *This drawing was done with a single pencil of medium hardness. The reflections and different surfaces are competently rendered, but a greater range of tones would have enlivened the overall grey: using pencils of different hardness would have made this easier.*

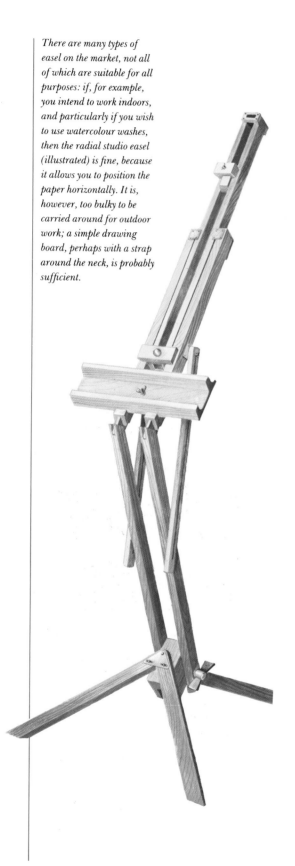

There are many types of easel on the market, not all of which are suitable for all purposes: if, for example, you intend to work indoors, and particularly if you wish to use watercolour washes, then the radial studio easel (illustrated) is fine, because it allows you to position the paper horizontally. It is, however, too bulky to be carried around for outdoor work; a simple drawing board, perhaps with a strap around the neck, is probably sufficient.

great variety of tinted and coloured papers available, many of them produced specifically for use with pastels. Many paper manufacturers produce pads showing the full range of their pastel papers. It is often a good idea for the beginner to obtain one of these pads to experiment with various colours, tints and grades of paper, to find what is most suitable for the type of pastel drawing he or she wishes to do.

Pencil covers a wider range of medium than is commonly thought. The lead pencil is now quite an uncommon medium, although still available. The lead pencil's light, silvery, grey line can produce an effect not dissimilar to that of silverpoint which, before the innovation of the modern graphite pencil, was the main linear drawing instrument, particularly among Renaissance artists, although that too is in less common use today. The silverpoint and lead pencil make their mark by leaving a small metallic deposit on the paper, which in the case of silverpoint can barely be seen when the drawing is first done. The metallic deposit tarnishes, and this increases the richness of tone in the line.

The graphite pencil as we know it today is still often incorrectly called a 'lead pencil'. It is a relatively new drawing instrument and has been in common use only for about 200 years. It comes in a variety of grades. The softest grades are denoted by the letter B and range from B to 8B, which is the softest. F, HB and H are in the middle of the range. H pencils are the hard range, from 2H to 8H. There are other grading systems but the H and B system is the most common. If in doubt, always test pencils before you buy them.

A useful alternative to the ordinary pencil, particularly for quick outdoor drawing, is the propelling clutch pencil, for which the 'lead' is purchased separately. This is particularly useful in that no sharpening is required and a fine line can be continuously maintained.

The solid graphite stick, normally graded approximately at 3B, is also very useful for larger, tonal, pencil drawings, and is often used in conjunction with a regular pencil. A number of artists recently have been drawing with raw graphite powder, rubbing it into the paper to make large tonal marks, then bringing out highlights with a rubber and more detailed areas with a regular pencil. This method is suitable for very large works.

A pencil can be used in a variety of ways but is most commonly employed in making a line; the result is a crisp, clear drawing. Shadow can be produced by hatching or cross-hatching, which is a set of parallel lines or two opposing sets of parallel lines, respectively. In the detail illustrated note that the lines follow the form, adding to the solidarity of the drawing by showing that part of the form that is turned away from the light but also giving a considerable amount of information about the surface

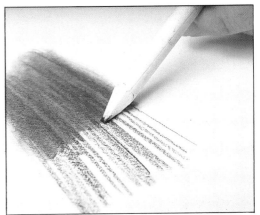

LEFT *A completely blended effect is not always required when using pastels; here the artist has decided not to rub in the colours, but to blend them roughly by using short strokes, thus preserving the contrast.*

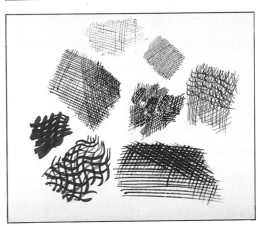

undulations of the form. This approach has been widely used, and two of its greatest exponents were Raphael and Michelangelo. In addition to cross-hatching, darker tonal areas can be shown by a series of regularly spaced dots. The softer variety of pencil can produce very soft areas of tone using the finger or torchon, or by spreading with a rubber. The flexibility of the pencil allows for a great amount of variation and experimentation that can help to decide what is the most suitable approach for a particular subject. The harder, smoother-surfaced papers are generally the most suitable for pencil drawing. A good-quality cartridge paper is most commonly used and is readily available in most areas. Coarser-toothed papers can produce some very interesting results with a softer-grade pencil, but generally the rougher papers are used less commonly with pencil.

A very large selection of coloured pencils and crayons is available, most of which are suitable for use in drawing, although some of the wax crayons have a tendency to fade quickly if exposed to strong light.

Wax crayons should really be used only for work of a temporary nature, such as for visualizing an idea in terms of its colour scheme. They can be quite useful for children's drawing because the colours do not smudge or blend together easily. The biggest problem (as noted above) is fading, which can be remarkably rapid.

TOP *Blending conte crayon with tortillon – a piece of paper tightly rolled to make a point – allows more control over small areas than blending with the fingers.*

ABOVE *Crosshatching with pen and ink – or any other medium – does not have to be a grid of parallel lines at a strict 45° angle; curved crosshatching, or cross-hatching in multiple directions, are particularly effective with black ink and a nib pen because the white of the paper is not totally obliterated.*

A modern variant of the wax crayon is the oil pastel, which has a much greater pigmentation and therefore does not have a fading problem. The richness of the colours available is similar to that of oil paint. Oil pastels can be mixed on the paper to a limited extent, but they do not blend as readily as regular pastels. Blending is best achieved by overlaying one colour on top of another, although some very interesting results are obtained by putting the oil pastels on the paper straight from the stick, and with the aid of a brush and turpentine an effect can be produced not unlike an oil sketch on paper.

A number of illustrations in oil pastel in this book also use pencil to enhance the form. Although oil pastels can be used with other media, it must be remembered that they are oil-based and do not readily interact with water-based or chalk-based media. For work out of doors, the oil pastel has many advantages, particularly for the artist whose finished work is predominantly in oils, because the colours are very similar in richness to oil paint.

Designers' coloured pencils are more permanent than wax crayons, although again they have a tendency to fade, some colours fading much quicker than others.

The real advantage of using coloured pencils out of doors is that you require no extra equipment such as brushes and water, and for creating coloured notes from nature in a sketchbook there is no more highly recommended medium. For the beginner a box containing about ten coloured pencils should be sufficient. As your experience expands, you can add to your selection of pencils those colours you find most useful for the type of drawing you are doing.

Coloured pencils are a much favoured medium for the graphic commercial illustrator when the finished work is going to be reproduced in a book or magazine, because the image is clear and reasonably easily photographed. In that from its original conception such work is intended for reproduction, the ultimate permanency of the medium is of little importance, so works in this medium have not really been subjected to any true test of time.

Most types of paper can be used with coloured pencils and crayons. It is advisable to use fixative on most drawing media such as charcoal, conte and crayon pencil. With wax crayons and coloured pencils it is not necessary and could even cause some damage to the work. Drawing media that are chalky or powdery require fixing to the paper, and this includes soft graphite pencil.

Fixative is applied either from an aerosol can or a mouth-activated spray. The aerosol cans are convenient but the ecologically conscious would almost certainly prefer to use a spray. The fixative can be obtained ready-mixed in a bottle. There are

in addition a number of old and well tried formulas for mixing fixatives. The application of fixative can be carried out with the drawing in either a vertical or a horizontal position. If the work is in a horizontal position, some care should be taken not to over-apply the fixative because it may cause runs, or to have the spray too close to the work. This latter caution relates particularly to works in pastels that can be blown off the paper when a mouth spray is used. Beginners are recommended to lay the work horizontally and to spray the fixative evenly across the surface so that it falls gently and evenly onto the work.

Ink, like charcoal, is one of the oldest media used for drawing. Ink can be applied with a variety of tools, from reed pen to brush. In modern times the most common way of using ink is with a steel-ribbed pen, although reed and quill pens still have their place on an artist's drawing table. These hand-cut pens can be shaped to produce the type of line that is required. Drawing with the brush also finds much favour, particularly in the Far East where a calligraphic mark is often used for drawing. This particular approach to drawing requires great skill and dexterity.

Many beginners are attracted to pen and ink drawing — although a certain confidence is required because ink marks can be erased only with a blade. The beginner normally starts with a line drawing and cross-hatching, and a great variety of hatching lines can be produced with the pen. These can range from careful opposed parallel lines (cross-hatching) to a free, almost scribbled mark, to produce tone. Artists such as Rembrandt drew almost exclusively in pen and ink, putting in large areas of tone with a brush and creating dramatic effects of light and dark. Of particular interest to the beginner using pen and ink are Rembrandt's landscape drawings. It was a common sight to see Rembrandt in the countryside around Amsterdam with an ink bottle tied to his belt recording the dramatic effects of light in that flat watery landscape.

Ink comes in a variety of forms and a very full range of colours. It is recommended that the beginner use a water-soluble ink, in colour either black or sepia. This type of ink allows for a full range of tones when used in conjunction with a little water. (The deepest tones can be obtained by using the ink at full strength.)

There is also available a full range of water-soluble felt-tip pens. The very finest of these can produce a line as fine as that produced by any mapping pen. Some very attractive drawings can be produced, and again areas of tone can be achieved by using water and brush. It is advisable to check, when purchasing one of these pens in black, that the ink when thinned with water is in fact black and not dark blue. It can be quite disturbing to find, part way through a drawing when applying water in order

Watercolour brushes for drawing need to be of good quality. Pure sable brushes are the best but the most expensive. There is now a very wide range of student quality nylon brushes on the market which, if well looked after, retain their point almost as well as sable brushes.

FAR LEFT, ABOVE *Scalpels, craft knives and trimming knives are surprisingly useful when drawing, for sharpening pencils and trimming paper, and even working on the drawing itself; for cutting fine lines into crayon, for example, or scraping away small areas of coloured pencil.*

FAR LEFT, BELOW *Nibs for dip pens; buy yourself a handful and experiment. The slip nib (1) produces a fluid line; the map pen (2) will give a line of varying width depending on the pressure applied. The crow quill (3) gives a consistent line width. The thick and thin strokes of the italic nib (4) are more angular than those of the script nib (5). The five-line nib (6) is perfect for regular cross-hatching. The copperplate nib (7) is angled to accommodate both vertical and horizontal strokes.*

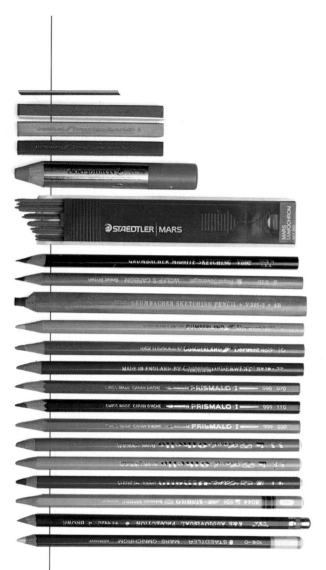

The pencil is a wonderful thing: not only is it infinitely various, it's cheap, so make sure you have a full range of graphite pencils of differing hardness. Charcoal and carbon pencils produce a very black line. The constituents of coloured pencils – filler, binder and lubricant – result in a soft lead which can usually only be removed with a blade.

to get some tones, that the resultant tones are in fact blue (which can look quite odd against a black line.)

Designers' reservoir pens produce very even and predictable lines. This type of pen is very useful to the beginner if it is constantly used. If, however, it is left for any length of time it dries out, and on a fine nib the blockage is then difficult to clear. This type of pen requires a certain amount of looking after. If you are going to concentrate your efforts on pen and ink, it is recommended that you use one of these pens; but if your use is to be only occasional, make sure you wash the pen after use so that the nib does not become blocked. Fountain pens with a fine nib and regular writing ink can also be a useful addition to your drawing equipment, particularly for outdoor drawing.

The harder, smoother-surfaced papers and coated boards are the most suitable for pen and ink drawing. A toothed (grained) paper can be used for coloured or tonal wash drawings where the amount of pen work is minimal. It is advisable to shrink the paper before you start. This is particularly true for pen and ink drawings intended to be tinted with watercolour. The combination of pen and ink with watercolour was a favoured medium for topographical artists on the Grand Tour of Europe in the 18th and 19th century. The fine detail was drawn from life and the watercolour tints added later. Some artists prefer to use bottles of ready-mixed watercolour, and these are available today in a large range of colours.

It is often a good practice, irrespective of the medium being used, to preshrink the paper. This is done by immersing the paper in water for about five minutes to get it thoroughly soaked, then laying the paper on a drawing board (which should be at least two inches bigger in every dimension than the paper.) Sponge off the surplus water and attach the paper to the board around all its edges with regular gummed brown paper. Allow the paper to dry naturally in a flat position. Once dried, the paper will not cockle again when washes in inks or watercolours are applied.

There is a great variety of sketching easels available. The traditional folding wooden sketching easel is still widely used, but there is also a good selection of metal easels. Although not absolutely essential, for any work that is going to take more than about half an hour to complete, the use of an easel of some type is recommended. The sketching easel also doubles as a studio easel for smaller work. It is not impossible with the minimum of carpentry tools to make your own easel.

A sketching stool is again almost essential if any work is going to be taken to a finished state when working out of doors; the discomfort of standing for an hour or more in one spot can start to destroy anybody's concentration. Any folding camping or fisherman's stool would be suitable.

ASSEMBLING A FRAME

1 *Secure a length of moulding in a mitre board or clamp. Position the saw and make the first cut.*

2 *Measure the required length of moulding along the inside of the rebate. Align the ruler with the mitred end of the wood.*

3 *Mark up the other end of the section of moulding using a set square to obtain the 45° angle of the mitre.*

4 *Mark the waste side of the cut, position the moulding in the mitre board, so that the cut is at the mark. Saw it through.*

5 *Cut all four sides of the frame. Apply adhesive to the mitred ends of the moulding.*

6 *Secure two mitred ends together in a corner clamp, so that an L-shape is formed. Make sure that the moulding lies flat.*

7 *Drill small holes into each corner. Secure the pieces with panel pins. Repeat process, join two halves of the frame together.*

If you are going to frame your favourite drawings, they will need glass at the front and a backing of hardboard.

The regular hard eraser is an essential item of equipment. However, for charcoal and pastel drawing a putty eraser should be used. It is very soft and can be moulded in the hand to make a point for lifting charcoal and pastel in areas of great detail. Ink can be erased on certain papers with a typist's hard eraser, but this is not a recommended practice because this type of eraser normally contains an abrasive and can destroy the surface of the paper quite easily. The more usual method of erasing ink is with a sharp blade, so that the ink is actually scratched off the surface of the paper. A scalpel is the best tool for this job. Care should be taken, however, because deeply scratched-out alterations can cause ink to run into the fibres of the scratched-out area if that area is redrawn. The erasing of ink should be left until the drawing has virtually been completed.

A regular craft knife can be used for sharpening pencils, crayons, etc., and can be used additionally for a variety of jobs in the studio. Scalpels with a changeable blade can be used for more delicate work.

LEFT TO RIGHT *Pentel and Staedtler Mars clutch pencils, and Venus graphite drawing pencil.*

1

2

3

4

5

Available in most art material stores in a variety of plastic and wooden equipment boxes with detachable trays to hold different items. Although not absolutely essential for outdoor drawing, a box that contains your equipment is extremely convenient. As an alternative to the purpose-made item, any old cigar box or tin is better than nothing.

Mounting and framing your work can greatly enhance its appearance, and choosing the right colour of mount, and the width and colour of frame, needs careful consideration. A delicate and sensitive plant drawing would be overpowered by a flamboyant, gilded, heavy Victorian frame, and the choice must suitably enhance and reflect the subject matter. As a general rule, drawings are presented to their best advantage in frames with simple-shaped moulding. For example, pencil drawings often look their best on a pale grey mount with a silver or metallic frame. The delicate and relatively negative quality of the pale grey mount and silver frame reflect and enhance the metallic nature of a pencil drawing.

Beginners often make the mistake of cutting mounts for their work that are far too dark and heavy. A black mount may at first seem exciting placed against a pen drawing, but unfortunately in most cases the mount draws so much attention to itself that it presents a stronger image than the drawing. Darker-coloured mounts, such as burgundy and olive green, should therefore be used with great caution in the framing and mounting of draw-

Tinted, textured papers are the most common supports for pastels. Ingres Canson (1) and Ingres Swedish Tumba (2) are manufactured in a large range of colours. Glass paper (3) is good for bold strokes and solid blocks of colour. Finely drawn detail looks marvellous on vellum (4). Mid-tone papers such as Ingres Fabriano stone grey, mid-grey and fawn (5) are useful for gentle, harmonious colour schemes.

ings. These strong colours really work only in conjunction with a robust piece of work.

Drawings never look very satisfactory when framed to the actual size of the drawing without a mount; generally, therefore, all drawings and works of a graphic nature require a card mount to separate the image from the frame.

For the beginner, the advice of a good professional framer can be invaluable: their experience can often enable them to intuitively choose the right mount and weight of frame for the work. For the more ambitious there is readily available a wide selection of wood and metal mouldings and mounting card, and with the minimum of equipment and a little skill it should not be too difficult for the student to mount and frame his or her own work.

The cutting of a good bevel-edged card mount could be more difficult than the making of the actual frame, however, and the following suggested sequence may be usefully noted. It is best if you cut your own mount internally about one-eighth of an inch smaller all round than your actual drawing, allowing on a small drawing about two inches between the mount and the frame. Fashions tend to change in relation to whether the mount should be an equal width all the way round or whether the bottom of the mount should be slightly wider. The original reason for the extra width was to allow space for a title or written description of the work to be shown on the mount. Visually, this title becomes part of the drawing, thus leaving an equal space to the other sides. Even when a title is not written, some artists prefer to have an extra weight of mount at the bottom, which can give the framed drawing a sense of stability.

Once the mount is finished, select the moulding you require and cut the mitres as shown. However, do not attempt to cut without an accurate 45-degree mitre block. When all four mitres are cut, assemble the frame and pins. The size and number of pins depend very much on the size of moulding and the weight of the drawing and glass. Do not attempt to drive in the pins without first drilling guide holes. Failure to do so almost inevitably results in the splitting and damaging of the moulding.

Once the frame is assembled, cut the card mount on the outer edges to snugly fit the frame rebate. Cut a backing to suit. At this point measure the internal dimensions of the rebate and get a piece of picture glass cut at your nearest glass-cutter's.

This sequence has been suggested for a beginner when assembling a frame becaue there is nothing more infuriating than making a frame and then discovering that the glass or the mount is a fraction too small or too large to fit. By making all the final measurements to fit the frame, rather than the frame to fit a predetermined glass measurement, the beginner should avoid such frustration.

The range of pastel tints available is vast; one light, one medium and one dark gradation of each colour is practicable, and a set of just 12 is probably adequate for sketching outdoors.

INDEX

Acknowledgements and Picture Credits

The author and publishers would like to thank Brenda Draper and students and staff of Cambridge School of Art who contributed work for this book including:
Rose Rands, Nelson Rands, Stephan Laplanche, Sophia Alyal, Chris Lunn, Matt Donovan, Alison Whittle, Susana Vazquez Liston, Pilar Larcade, Nicola Edwards, Maureen Carter, Ben Wee, Sarah Parkinson, Nicola Dober, Julia Blackbeard, Kaoru.

The National Gallery pp6, 72a; Robert Harding p98a; Gerald Cubitt p98b; Kate Atkinson p99; RIBA p112; Sotheby's p113; Sanderson's pp114, 115a; The American School of Classical Studies, Corinth excavation, p115b. Artwork photography by Bob Cross.